IMAGES
of America

PINE CITY

On the cover: Please see page 50. (Courtesy of Earl James Foster.)

Nathan Johnson

Copyright © 2009 by Nathan Johnson
ISBN 978-0-7385-7740-1

Published by Arcadia Publishing
Charleston, South Carolina

Printed in the United States of America

Library of Congress Control Number: 2009932236

For all general information contact Arcadia Publishing at:
Telephone 843-853-2070
Fax 843-853-0044
E-mail sales@arcadiapublishing.com
For customer service and orders:
Toll-Free 1-888-313-2665

Visit us on the Internet at www.arcadiapublishing.com

For the people of Pine City, all of whom helped make this rich history

Contents

Acknowledgments		6
Introduction		7
1.	In the Beginning	9
2.	Transplanting a Village	21
3.	Street Scenes and Aerial Views	49
4.	A Way of Life in Pine Society	81
5.	Standing Tall	107
Bibliography		127

Acknowledgments

The photographs in this book were selected almost exclusively from Earl James (Jim) Foster's personal collection, which he assembled from many sources. Heartfelt thanks go out to the photographers, many of whom are now deceased.

Without the help of Jim Foster and Alaina Lyseth, this book would not have been possible. Jim's passion for Pine City was vividly evident from the amount of time and resources he put into research toward this cause, and Alaina was diligent in continuously suggesting useful sources and in fact-checking. Both of them reached out to the various local experts on Pine City's history for information and clarification.

Also to be commended are those who have written about Pine City's history within the Pine County history books. Each one gave insight into the beginning years. Special thanks to the Pine City branch of the East Central Regional Library for providing copies of books for often-extended periods of time. The Pine County Historical Society, of which I am a member, espoused this effort.

Also, thanks to each of the following collectors of photographs for making this version of Images of America possible: Clark Foster, C. J. Gustafson, Fritz Johnson, Pine City Pioneer, Central Minnesota Coin and Antiques, Sam Klemet, Margery Strattle Swanson, Mike Sauser, Pine City High School, Sandy McKusick, Jennifer Rydberg, Joyce Lindquist, Scott Cummings, Bob Thiry, Jennie Olson, Carolyn Miller, Marion Larson, David Hill, Marion Lones, Mary Pawlenty, Marina Vork, and Vicki Foss.

Mercifully, my family, Randy Johnson (Dad), Wendy Johnson (Mom), Natalie, and Nick; best friend, Annie; and mentee, Cody, supported my interests and efforts and put up with my distractions. I also appreciate wholeheartedly my aunt Angela Foster for her editing abilities and my grandmother Helen Foster, who gave a wonderful depiction of times past.

Unless otherwise noted, all images are courtesy of Earl James Foster.

INTRODUCTION

The first colony in the area may have been established in 1841 by a Mr. Kirkland of Illinois, but it was said that there were tensions between him and those native to the land. In the years that followed, settlers gradually began to infiltrate the area, especially when the logging industry began to boom. A reverend and his wife began a Protestant mission and school, and the two cultures began to adapt.

The beginning part of the story gives insight into what later became known as Pine City. The individuals whose pictures are in this book played a significant historical role, but certainly there were others. Take for example Julius Dosey, who was active in both logging and politics. He served on the original village council in 1882 for 22 terms, either as a member or as mayor. In 1898, he lost a tied mayoral election by the toss of dice to R. P. Allen.

Dosey was born in Wittenberg, Germany, on June 9, 1851, and came to the United States in 1868. Two years later, he came to the Native American village of Chengwatana. He came as a youth at the time when J. S. Pherson built the community's first sawmill. He later began to log on his own and united in marriage to Elizabeth Drews. They had two sons and four daughters. He died on March 8, 1932.

Other factors also shaped the history of the area. The Government Road, built from 1854 to 1857 over an old Native American trail, gave people access to the region. Using axes and shovels as tools, 12 men started in St. Paul and 12 from Superior; they met in Chengwatana. On July 1, 1857, Gen. W. W. Wheeler announced that the road was complete and open for year-round travel, at a price tag of about $20,000. Chengwatana was one of the few locations along the route that offered overnight accommodations.

Copper prospecting nearly brought Pine City some fame in its early years when it was thought to have been discovered nearby. A stock company with $250,000 of capital was formed and sank 150-feet-deep shafts into a rich deposit area. But that prospect did not turn out.

The story of the early years of Pine City is the story of people enticed by land made available by the Homestead Act of the 1860s, which gave people title to 160 acres to homestead outside the original 13 colonies. One of those who settled in the area was John D. Wilcox. Born in Erie County, Pennsylvania, in 1829, Wilcox established a sawmill at Taylors Falls in 1853. Wilcox moved to Chengwatana Village and lived there until 1872, serving in many public offices. He was superintendent of schools for 6 years, county attorney for 12 years, judge of probate for 6 years, register of deeds for 5 years, and county surveyor for 12 years.

Later Dr. Robert Wiseman moved to Pine City after graduating from the University of Minnesota in 1897. He was a member of the fire department and also the county coroner. Once, he was summoned to the scene of a tornado disaster in Brook Park in 1911 where two were killed. A park was dedicated in memory of him, to the south of Robinson Park.

In 1919, there were four churches in Pine City of Lutheran, Catholic, Methodist, and Presbyterian faiths. The history of the Our Redeemer Lutheran Church goes back to the early 1900s. In 1946, the actual congregation began when Milburn and Pine Grove Lutheran Churches merged due to the general decline of population in the rural areas. In 1947, the church was established after the building was moved from the country and remodeled. In the 1970s, when the congregation grew to larger than 600 individuals, the space was not large enough. While Kenneth Manfolk was pastor, the church was able to purchase land on the south end of the city to build a new church facility.

Several Pine City sports teams are also mentioned later, but besides the usual football and basketball recognition, the extracurricular group to most distinguish itself was the agricultural

department, under A. A. Hoberg's leadership, with two national championships in judging poultry and poultry products, eggs, and dressed poultry. It won $900 at Waterloo, Iowa, in a national judging contest with eight gold trophies and three silver ones. The Minnesota Farmer also gave it the gold award for having the highest average of any school in the state for judging.

Although Pine City was a recreation haven before then, in the April 30, 1925, newspaper, it was announced that Pine City was to have a golf course and 20 members were already enrolled in the golf club. A temporary golf course was laid out on the fairgrounds where a seven-hole course allowed linksters to get their practice in until less-cramped arrangements could be made at the new course. The fairgrounds course was opened on May 14, 1925, with the president being Ben Boo, George Olson as vice president, and Dr. Alf K. Stratte as secretary-treasurer.

Over the years, there were lots of entertainment options in Pine City. The Walt Schwartzwald family owned the Crystal Ballroom, which was built in the 1930s, with a four-lane bowling alley addition in 1939, the only alleys between the Twin Cities and Duluth. Schwartzwald also built the town's first car wash and first trailer park, as well as a drive-in theater. The Schwartzwalds left Pine City for California in 1946 but returned to Pine City to buy the Family Theater in 1948. In 1949, they started construction on the Schwartzwald Motel. In 1952, 22 units were added to the present motel. The family built the Pine Outdoor Theater in 1957. In 1960, they sold the motel to Al Dusek, and in 1965, they built the King Koin car wash.

The Family Theater was located along Third Avenue Southwest, just a half block west of the highway. In the late 1950s, VFW Post No. 4258 paid for a movie to be shown there on Halloween for the children of the community. Members helped out and gave popcorn to each child as they came in. Santa Claus would visit the theater during the holidays. Ted Buselmeier owned the Family Theater for a time. The show house had 1940s red carpet and curtains. Dr. Olson's dental office was upstairs.

Pine City has always held its servicemen and servicewomen in high regard. Pine County residents have served in all the wars since the Civil War. The B. F. Davis Post No. 137 was organized on May 5, 1885, by veterans of the Civil War. The following names appear on the charter: J. Davis, J. E. Netser, J. F. Stone, M. Heath, A. G. Perkins, T. P. McKusick, N. B. Hoffman, C. Pitt, J. McLoughlin, Joe Osier, J. Haughten, J. Pervonchee, M. Dunn, G. Ruff, and H. Brandes. Associated with this, the Ladies of the GAR, Emily J. Stone Circle No. 16, was organized, and it presented a memorial bronze tablet with the above names as well as others on it.

During World War I, 1,087 Pine County residents served their country, of which 44 were casualties. After the war, the local American Legion and its auxiliary were organized. In 1924, Battery E of the 125th Field Artillery of the Minnesota National Guard was activated in Pine City. It was mustered into federal service on February 10, 1944, and saw service in Europe. In World War II, 2,820 persons from Pine County served, of which 84 gave their lives.

This book was never meant to be a comprehensive history of Pine City. There is far too much history in the community to include it all within these 128 pages, as there have been successive incarnations of Pine City over the years, with history and character coming in waves. From the early Ojibwe village to a New England lumbering town and then a farming community that has been home to Scandinavians, families from Appalachia who spent a generation or two in Iowa, and Bohemians, along with many others, Pine City has continuously evolved. Farming, in particular, came with a challenge—a tilt toward poverty because history and geology met here in a tough reality as cleared former pine forest meant poor soils and thus difficult farming.

Having more than its fair share of poverty, the city took a blow during the Depression, as is also the case in today's economic environment in much of rural America. This long-standing economic reality has created a constant developmental theme: tension between folks' genuine economic need to leave things the same and younger folks' wish for a more happening place. Nevertheless, Pine City continues to be a city of great history while also moving forward, providing the community with such fine amenities as Pine Technical College and an ever-growing technology-based industrial park. This book aims to capture highlights of this history and the unique people who made it.

One
IN THE BEGINNING

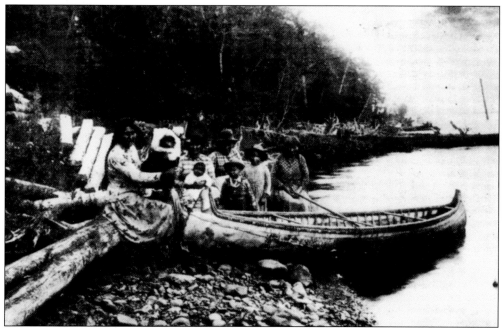

Before Pine City was incorporated as a village, the junction of Cross Lake and the Snake River had been the site of a Native American village, Chengwatana, which translates from Ojibwe to "City of Pine."

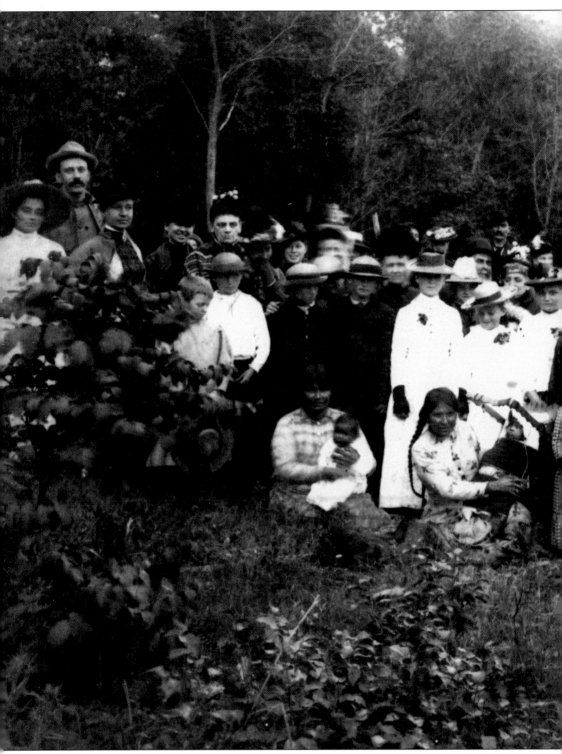
Seen here are Caucasians and Native Americans together, near the site of what was the Pokegama Mission, a Protestant mission set up to teach Christianity to the Native Americans.

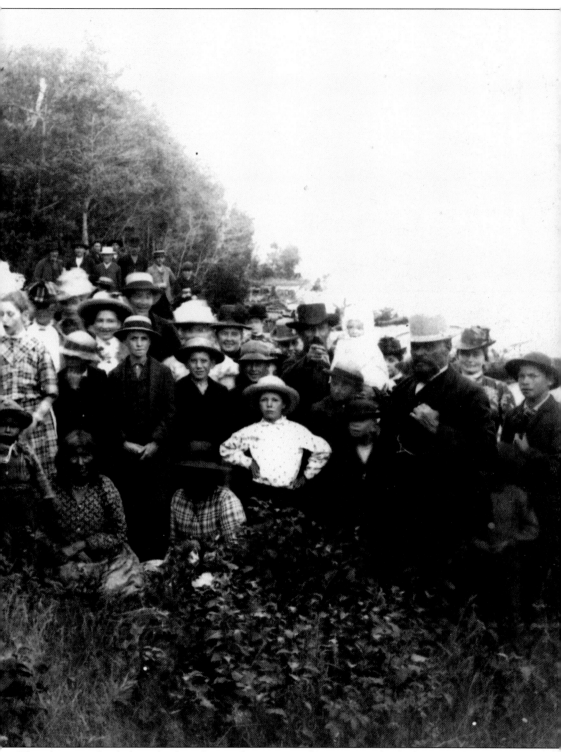
This photograph is believed to have been taken in 1892, during a Fourth of July picnic. (Courtesy of Pine City High School.)

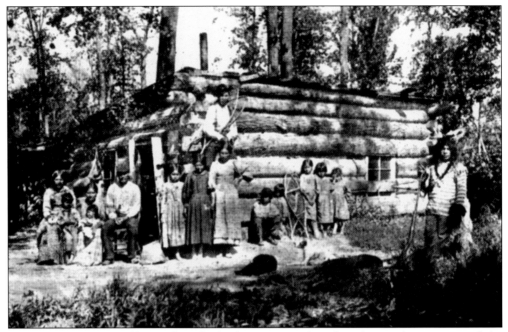

Chengwatana was a rallying place for both natives and traders due to the junction of the two waterways. The photograph above shows where medicine was provided for the natives at nearby Pokegama.

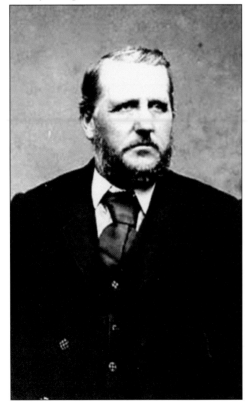

Caucasians moved into the area, among them missionaries such as the beloved Rev. Frederick Ayer. In the early 1830s, Reverend Ayer established the Pokegama Mission and school and was credited with bringing in the first printing form to print the Bible in the Ojibwe language. Once the mission was set up, the government sent an agricultural specialist, Jeremiah Russel, to create the area's first farm. The two cultures learned from each other.

The wife of Reverend Ayer, Elizabeth Taylor Ayer, was born in Massachusetts and became a prominent teacher. Before moving to near Pokegama in 1836, she was the first assistant to Mary Lyon, the founder of Mount Holyoke College (then Mount Holyoke Female Seminary) nearly a century before women gained the right to vote.

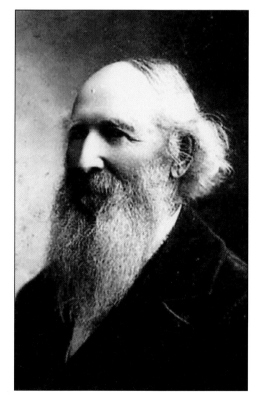

Born in 1834 to Rev. Frederick and Elizabeth Taylor Ayer, Lyman Warren Ayer was the first Caucasian born in Minnesota. He was well known statewide as a surveyor and author. He worked for the government, taking a count of natives for the 1920 census. Heart trouble took his life on his way to a firefighters' convention in Pine City when he was 86.

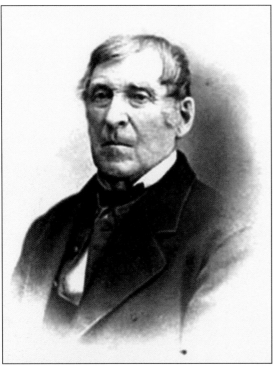

Rev. William Boutwell was the first missionary at Leech Lake. He later came to the Pokegama Mission and stayed after it was broken up by the Sioux.

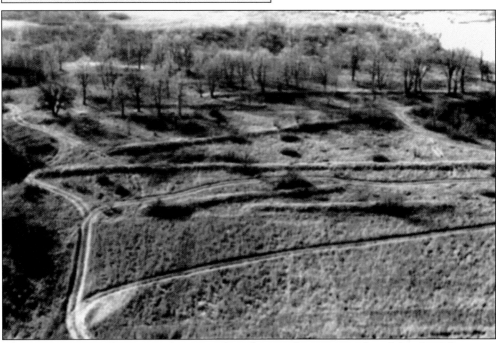

The Stumne Mounds, Native American burial grounds, were purchased by the Minnesota Historical Society in 1968 and were entered into the National Register of Historic Places on June 20, 1972. The mound site has been closed to the public and held for preservation by the society since that time. Adjacent to the Stumne Mounds site are the Vach Mounds. Artifacts placed these mounds at 4,000–5,000 years old.

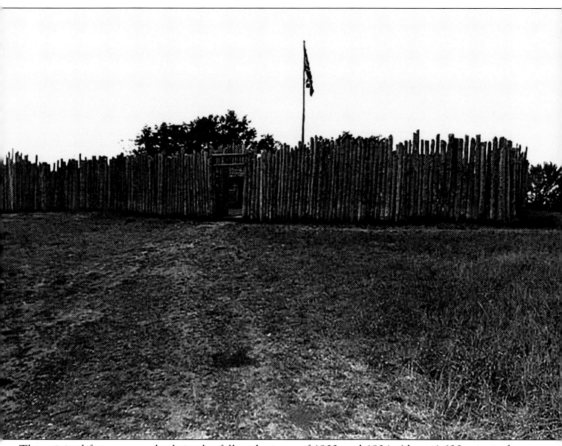

The original fur post was built in the fall and winter of 1803 and 1804. About 1,600 tamarack poles were cut and used to construct the stockade. The post was ideally situated on high ground about 150 feet from the river, connected to the outside world through the Snake, St. Croix, and Brule Rivers to Lake Superior. The post was used for several years but was later abandoned and destroyed by fire. The site of the post was discovered by Joseph Neubauer, who interested the Minnesota Historical Society in its potential. Archaeological work began in 1964, and reconstruction of the post commenced in 1968. The restored northwest post is the only restored post of its kind and attracts thousands of tourists and fulfills an important link in interpreting local history. It was placed on the National Register of Historic Places on August 7, 1972.

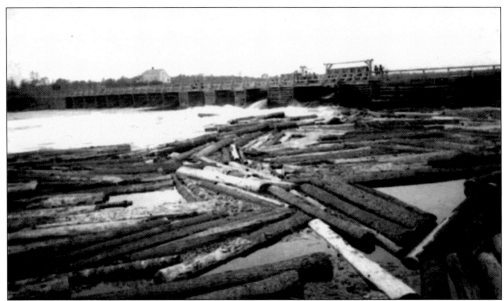

This photograph shows the original Chengwatana sluice toll dam built in 1848 on the Snake River near its outlet from Cross Lake. The dam was the first commercial business venture of any scale in Pine County. It was used for logging purposes until 1898 when a flood damaged it. The original dam was repaired by the Munch brothers. The Eastern Minnesota Power Company later bought the Chengwatana Dam from the Munch brothers. In 1902 and 1903, failed attempts were made to blow it up with dynamite. In 1912, it was taken out by court order.

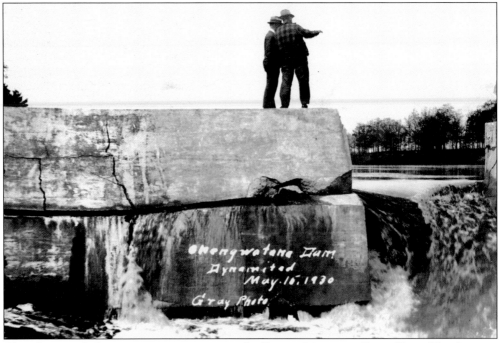

This photograph shows two men peering over the Eastern Minnesota Power Dam. The dam was servicing roughly 30 communities by the time it was sold in 1928 to the Wisconsin Hydroelectric Company. The photograph says the dam was dynamited in May 1930.

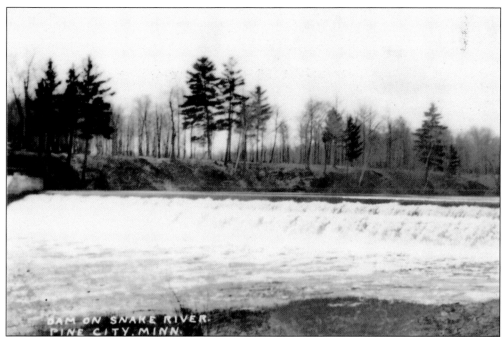

These postcards show other views of the power dam.

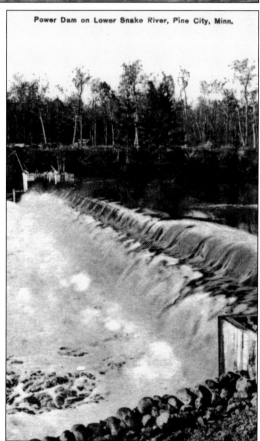

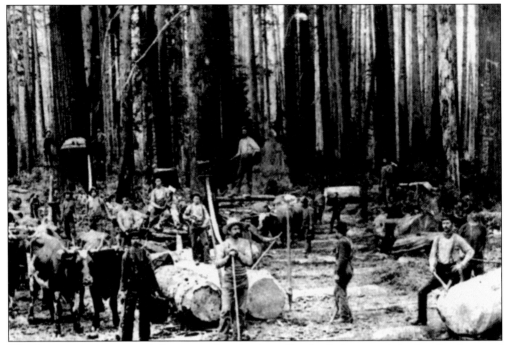

This logging picture gives readers an authentic view of lumberjacks at work in the pine forests of Pine County. This picture shows the immense size of the virgin pine trees that covered the area and were cut and floated down the Snake River at Pine City. Teams of oxen were used to drag the huge, heavy logs out of the forests and to the riverbank for their journey south.

Elam Greeley was an early pioneer lumberman who settled in the area in 1849. He was born in Salisbury, New Hampshire, in 1818. In 1840, he came to St. Croix Falls, then to Stillwater, and then farmed an area just southwest of Pine City. The barn on his homestead was used for storage of lumber transported between this area and Marine Mills in Washington County. Greeley died on September 14, 1883, and was buried at Stillwater.

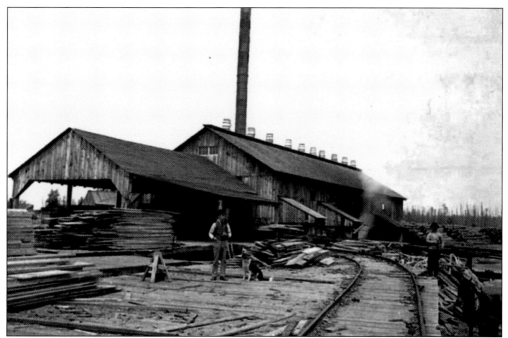

Around 1868, Pine City had established itself as a logging camp. Many early lumbermen from the eastern states came to Minnesota after their forests were depleted. The news of giant pines and unending forests brought these men with logging experience to Pine County. This photograph shows an area lumber mill.

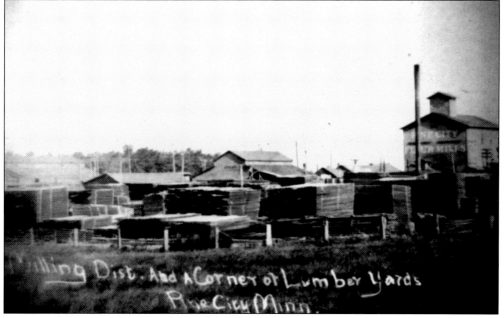

Pine City was a rough lumberjack town by fall and spring—by fall when men prepared for winter cutting and again by spring when the drive was in. The logs were sent to Stillwater, the main milling center for the region. Logging was at one point the biggest industry, and at various times, there were large sawmills in town. This photograph shows a lumberyard of Pine City's past.

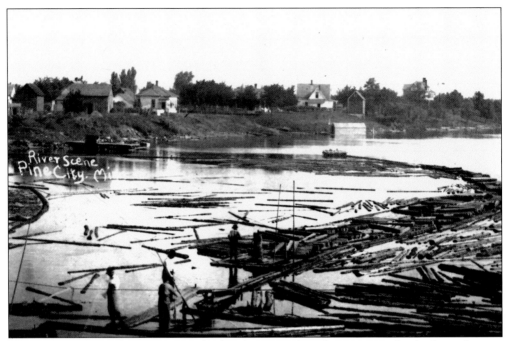

Over time, Pine City became more of a distribution and outfitting center for the larger logging operations in northern Pine County. In this photograph, facing the north shore of the Snake River, several men are at work.

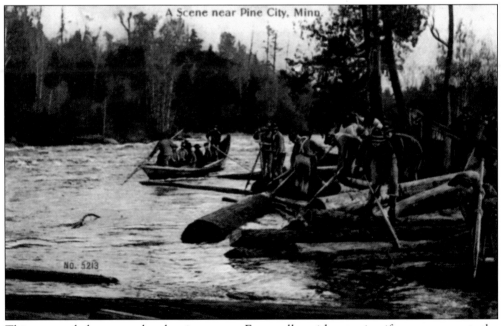

This postcard shows another logging scene. Eventually, without scientific management, the logging industry wore itself out and much cutover land remained.

Two
Transplanting a Village

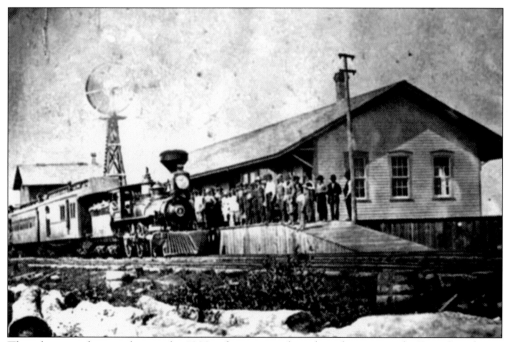

This photograph was taken in the 1880s of passengers boarding the train at the Pine City depot. This is a St. Paul and Duluth Railroad train line, leased by the Northern Pacific Railway to provide a link between Duluth and the Twin Cities, later purchased outright by the Northern Pacific. The photograph was taken facing north.

Pine City grew at a brisk pace with the number of families that deboarded the train to make this their home.

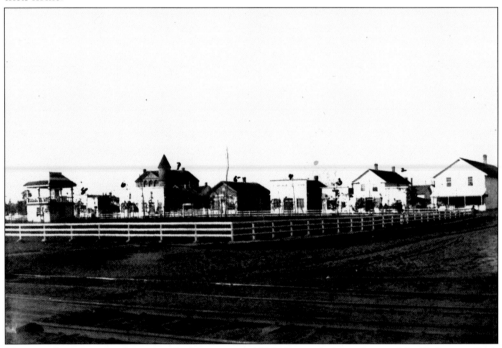

Train tracks are in the foreground of this spring 1888 photograph, in front of the Robinson Park town square. At this time, the trees of the park were small, and there existed a wooden fence around the park and an ornate bandstand in the center. The buildings behind the park are, corresponding to numbers, (1) Glasow Store, (2) Breckenridge Pharmacy, (3) millinery store, (4) Brandes (or Tierney's) Saloon, (5) Borchers home and shoe store, (6) unknown restaurant, (7) courthouse, and (8) Pat Connor Saloon, on the corner. This block burned in 1897. (Courtesy of Marina Vork.)

This bridge replaced the wagon bridge of 1887, the village's first bridge. The wagon bridge, seen in the distance in the photograph below, was constructed when the state appropriated $1,500 to the village to build it. When first constructed, the bridge was quite a noble piece of architecture and a pride of the community. It reared its head in haughty disdain as the old *Dirty Bess* steam tug would chug along beneath its tow of logs.

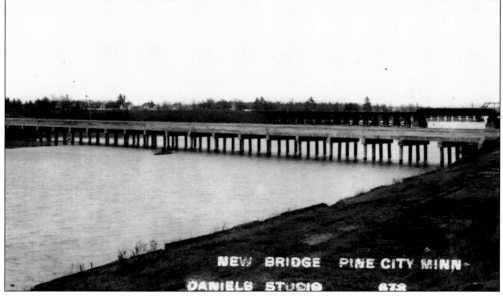

Photographed here by Ross Daniels is the extensive Pine City infrastructure, three bridges across the river. The closest bridge was the result of the village's growth and the need for motorists to cross the Snake River. The middle bridge was used for trains traveling to and from the depot. The far bridge was the wagon bridge. This photograph faces northeast toward the Woodpecker Ridge Neighborhood. This neighborhood's name came from all the slashing and burning that took place on the other side of the river. The high ground was a haven for woodpeckers.

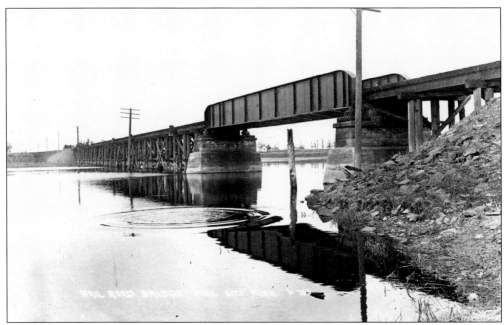

This photograph, taken in 1920–1930 from the south bank of the Snake River, shows the railroad bridge on its own.

The Brandes home was Pine City's first home. It was a log home built by a family by the name of Brandes in 1869 for the depot agent, a Mr. Soest. A second Brandes family, thought to be related to the first, moved into the house in the 1870s or 1880s. The most notable and memorable occupant of the home, which changed hands many times, was Dr. Robert Wiseman. In its last years, it was used as the American Legion. It was torn down in 1968 to make room for the nearby bank's parking lot.

Born in 1870, Will E. Poole was known as one of the greatest photograph artists of the Northwest, offering artistic lighting and posing alternatives to his clientele. In addition, he had an expertise in portrait painting. After learning the trade from J. R. Snow of Mankato, he moved to Pine City and established a first-class gallery in the community with the most up-to-date and finest paraphernalia of the time.

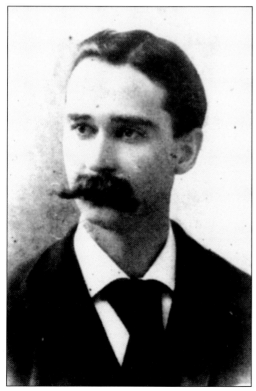

A. W. Piper was a prominent citizen of Pine City, after having moved to the village in 1899. He opened a business in the following realms: furniture, undertaking, upholstering, crockery, glassware, pianos and organs, pictures and framing, wallpapers, carpets, and rugs.

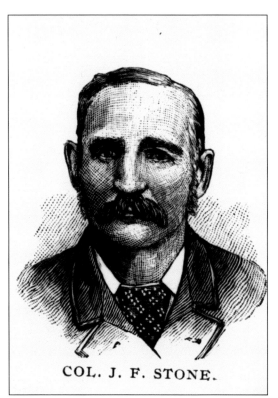

COL. J. F. STONE.

Col. J. F. Stone, born on March 2, 1839, was a prominent figure in town involved in real estate, copper mining, local schools, and hotel ownership as well as writing and poetry. Along with L. H. McKusick, he was one of the first teachers in Pine City. A Democrat, he served for a time as president of the village council. His great-grandfather Thomas Stone was one of the signers of the Declaration of Independence.

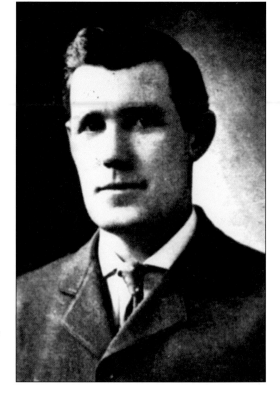

James MacLaughlin was sheriff for many years and was succeeded by his son-in-law R. J. Hawley (photographed here), who served until his death in 1927. Hawley was born on February 11, 1872, and served as village marshal for years and became deputy sheriff before being elected sheriff in 1898. He was beloved by his constituency and reelected in 1900.

Emil Munch, one of three Munch brothers, moved to Chengwatana in 1857 and held most of the early village/county offices. He was a member of the Minnesota House of Representatives, Second District (1860–1861), and Minnesota state treasurer (1868–1872). He was a wounded veteran in the battle of Shiloh, having enlisted in the 1st Minnesota Artillery Battery. He died on August 30, 1887. His brother Adolph was a member of the Minnesota House of Representatives, 28th District, in 1872.

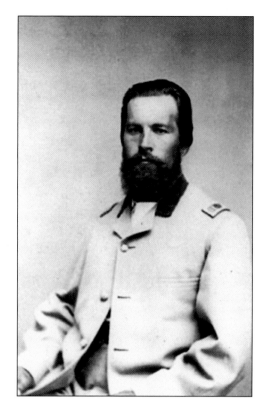

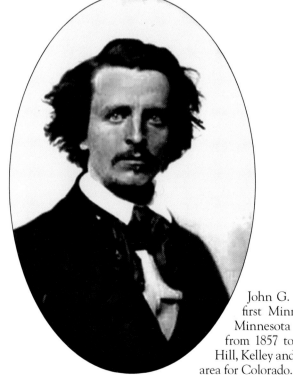

John G. Randall, a logger, was a member of the first Minnesota state legislature. He served the Minnesota House of Representatives' 25th District from 1857 to 1858, when this portrait was taken by Hill, Kelley and Company. In the 1860s, Randall left the area for Colorado.

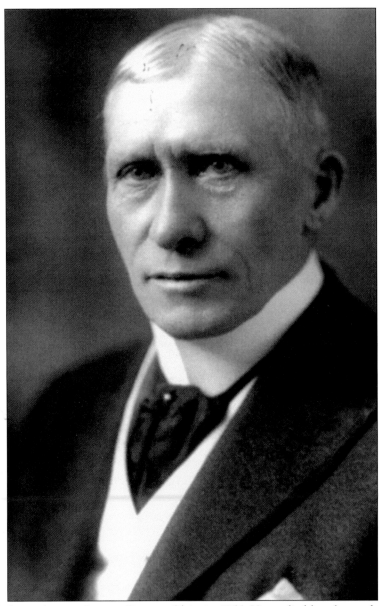

J. Adam Bede was born in Lorain County, Ohio, in 1856. He studied law, learned the printer's trade, and worked as a writer for several newspapers in the West and South. He moved to Pine City and became noted as one of the most distinguished residents to have lived in Pine County. He printed *Bede's Budget* in Pine City for several years and founded the *Pine Poker* in 1897, which received its name because Bede enjoyed prodding and poking people with ideas. Besides being a publisher, he was also engaged as a lecturer and noted for his humor and speaking style. He served as United States marshal for the district of Minnesota in 1894 during the great railway strike, and he was elected to Congress as a Republican (March 4, 1903, to March 3, 1909). Bede then moved to Duluth in 1927 and died there on April 11, 1942. He was buried in Birchwood Cemetery in Pine City. The Bede residence, of classic East Lake style, is from about 1906. The first tennis court in Pine City was at the Bede home, and when the clay court became too hard to keep in shape, Bede had a concrete court built.

Pictured in this photograph are some of the early women of the community (order unknown): Elizabeth (Lizzy) Breckenridge, Alta Stephan, Hattie Pennington, Maria Borchers, Mary Roberts, Nettie Miller, and Carrie Hodge. (Courtesy of Sandy McKusick.)

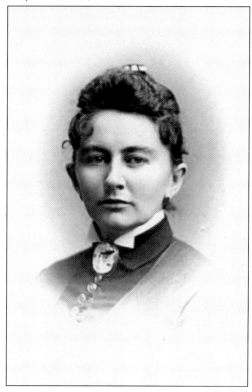

One of the women above, Elizabeth (Lizzy) Breckenridge, was one of the first female pharmacists in Minnesota. Born in 1859, the daughter of Emily J. McKusick and John F. Stone, she became a teacher in Maine, where she grew up. She came to Pine City in 1879 where her parents opened the Pioneer House. She taught at Pine City and Hinckley and in 1886 was married to John Breckenridge. In 1880, she and her aunt Alice McKusick ran a drugstore (later known as Breckenridge Pharmacy for over 40 years). Elizabeth was the oldest-living registered pharmacist in the state of Minnesota. She died in 1942 in the family home built on the site of the Pioneer House, which was destroyed earlier in a fire.

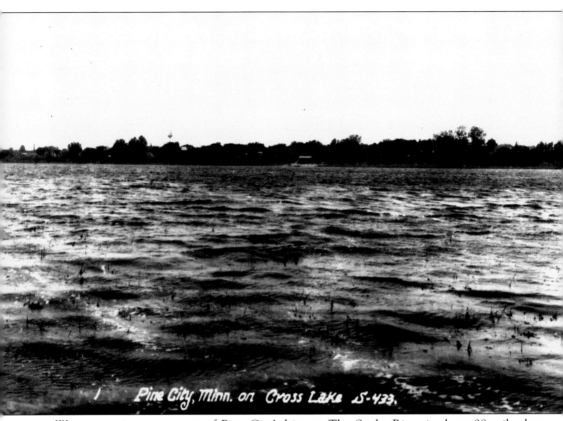

Water is an important part of Pine City's history. The Snake River is about 98 miles long, flowing from its headwaters to the St. Croix River, 13 miles east of Pine City. The only two lakes associated with the Snake River are Pokegama and Cross. Cross Lake, shown in this photograph, is a translation from the Ojibwe word *bimijigamaa*, meaning "a lake that traverses (another body of water)."

The city's first beach was on the southwest part of Cross Lake, a lake roughly 943 acres in size.

Pictured here is Norway Point, a peninsula near the northernmost part of Cross Lake.

These are photographs of Devils Lake, another of the bodies of water that encircle Pine City. It is about 18 acres in size and located just southeast of the community.

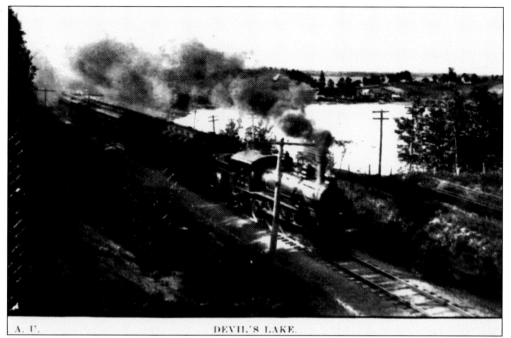

This photograph depicts a train traveling past Devils Lake. Local legend has it that the lake once swallowed a train that has never been found. It is said that in the 1800s, a circus train derailed into the lake, which measures about 90 feet deep, and is still at the bottom. (Courtesy of Jennifer Rydberg.)

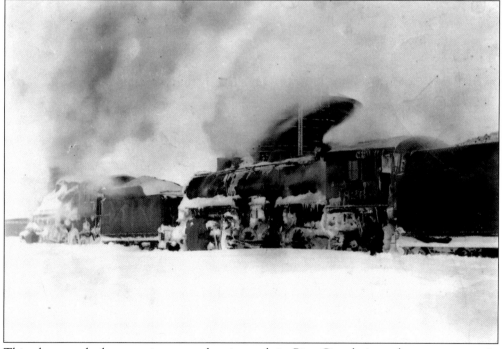

This photograph shows an ice-covered train stuck in Pine City during a large snowstorm in about 1920. (Courtesy of Jennifer Rydberg.)

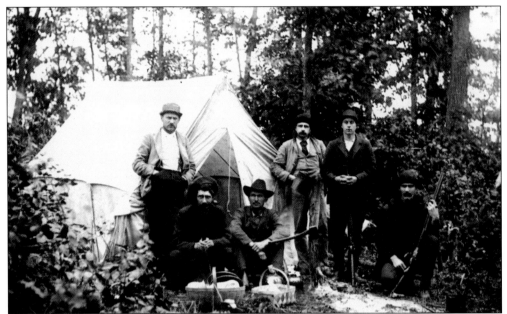

This is an 1892 photograph of a hunting party at Pokegama Lake. The campers are (from left to right) J. H. Hay, superintendent of the school; W. J. Gottry, printer of the *Pine County Pioneer*; A. W. Lawson, Lakeview House hotel keeper; Morrie Edwards, printer of the *Pine County Pioneer*; Charley Nason, student; and W. P. Gottry, printer of the *Pine County Pioneer*. This lake is roughly 1,474 acres and gets its name from the Ojibwe word *bakegamaa*, meaning "a side-lake (of another body of water)." (Courtesy of Central Minnesota Coin and Antiques.)

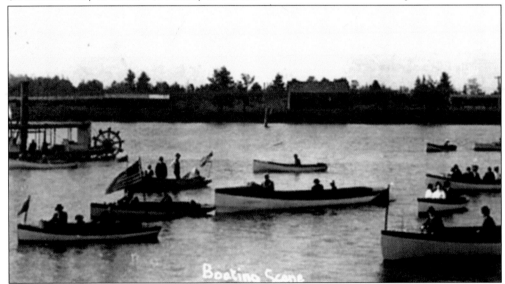

Boating was quite a popular activity on the Snake River in 1910, as can be seen in this postcard. The photograph is thought to have been taken looking north at about the spot where the Main Street bridge now stands. The stern-wheeler belonged to the owners of the Fritzen's hotel, which was located on Pokegama Lake. Boats in the foreground belonged to Walt Gottry, Butch Hoefler, Jake Kalable, P. W. McAllen, Norris Edwards (background), J. A. Peterson, and S. G. L. Roberts (big boat, foreground right).

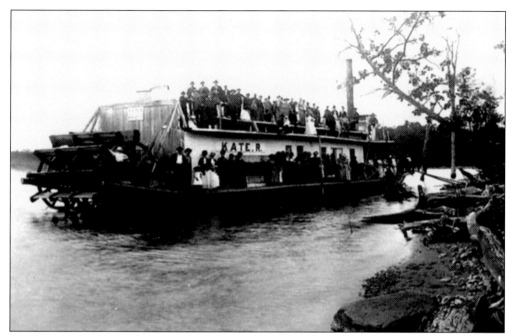

The *Kate R.* was a 125-foot stern-wheeler that plied the Snake River with up to 80 passengers and cargo. It was built in 1879 and ran until 1888 when the Great Northern Railroad completed its track between the Twin Cities and Superior, Wisconsin. Dick Robinson owned it and named the boat after his wife. It was piloted for many years by Capt. Elijah Seavey, who lived in the village.

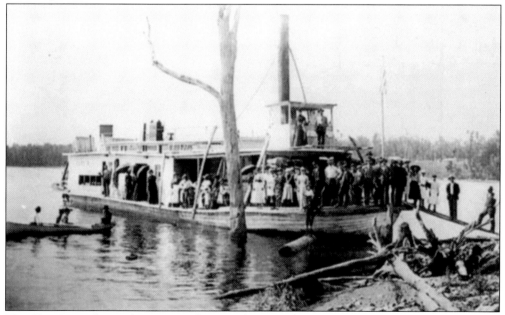

The *Kate R.* made regular stops at the Tuxedo Inn, one of the finest resorts on the lake, and other various locations. Once the railroad came in, the steamboat's freight business fell off. In 1888, it was hauled out of the water and rested above the riverbank where the local fairgrounds are now located. It remained there for several years, gradually being dismantled.

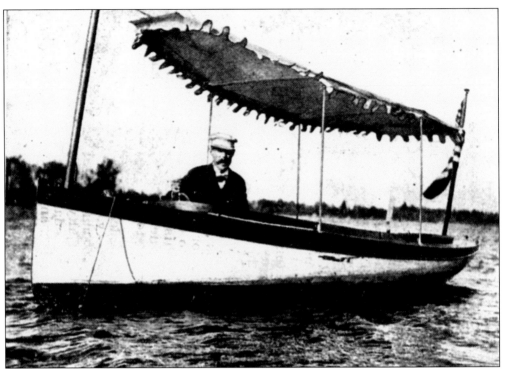

In the spring of 1899, this photograph of S. G. L. Roberts was taken on Cross Lake. Roberts, who was Pine County attorney at the time, is seen in his launch, the *Deborah*, which was the first gasoline engine–propelled boat on the Snake River and Cross Lake. Roberts was born on December 24, 1864, and established residency in Pine City in 1899. A year later, he became the state nominee on the Democratic ticket for attorney general. Roberts's law offices were in the Rybak Block.

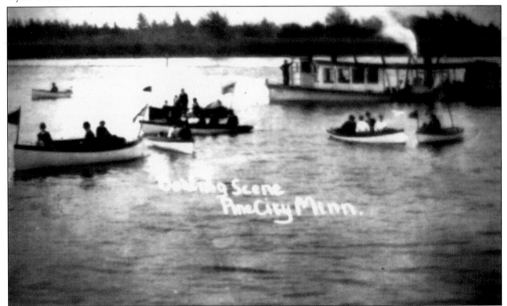

This Pine City boating scene is further demonstration of boating's popularity in the area.

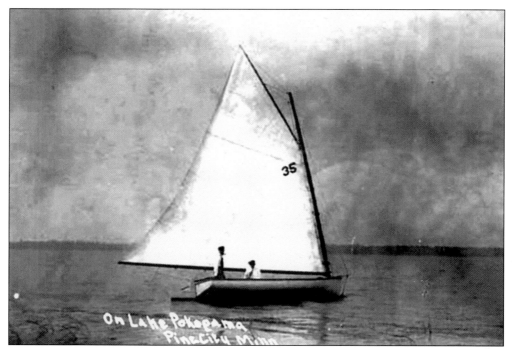

These sailors on Pokegama Lake appear to have had the lake to themselves when this photograph was taken.

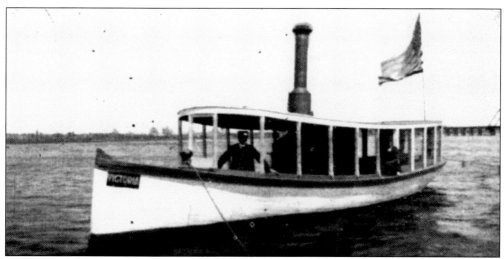

Steamboat excursions became popular for tourists and as a pastime for locals as well. The *Victoria* (pictured above), *Stowe*, *Cumberland*, and *Kate R.* were some of the best-known boats. The *Victoria* made regular trips from the Pokegama Park Hotel connecting with each incoming passenger train at Pine City.

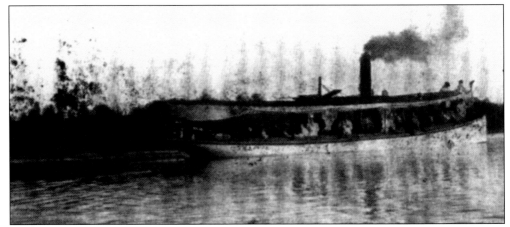

In this photograph is one of the hardest-working steamboats to ever ply the Snake River and local lakes during the 1890s, the *Stowe*. Fritz Johnson served as the engineer for four years to this passenger and tug boat. The craft was built in St. Paul in the winter of 1894–1895 and was launched in the Snake River on May 22, 1895. It hauled logs, freight, anglers, and excursion parties between the lakes until shortly after the flood of June 6, 1898, which washed out the Chengwatana Dam. In 1899, the year the dam was rebuilt, the propeller steamer was sold and taken to Leech Lake at Walker.

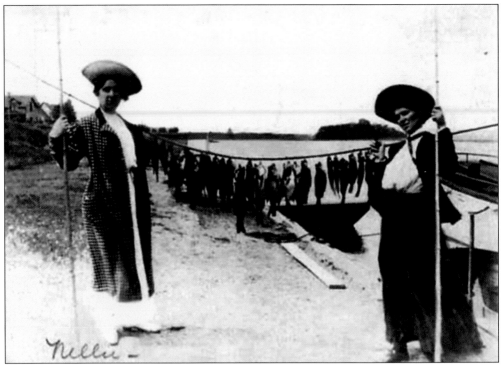

Fishing has been a popular activity throughout Pine City's history. Pictured here are two women showing how many fish were caught in one hour's time on Pokegama Lake.

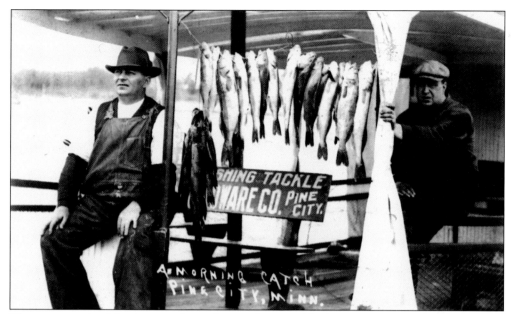
The two men in this photograph surely were happy with their morning catch. (Courtesy of Central Minnesota Coin and Antiques.)

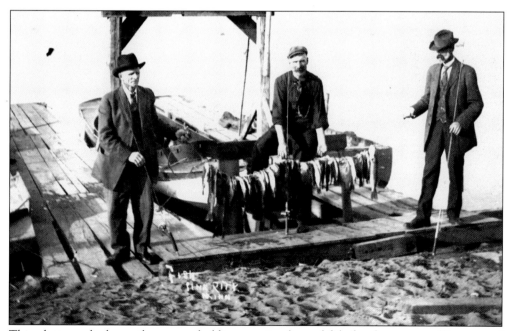
This photograph shows three men holding a string line of fish for the camera. (Courtesy of Central Minnesota Coin and Antiques.)

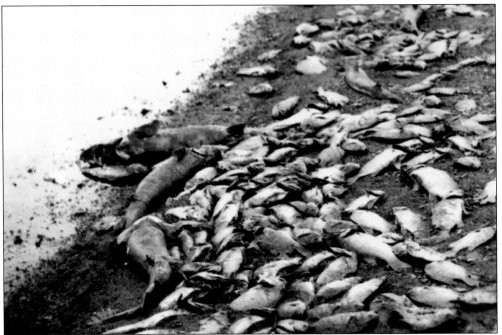

This 1926 picture shows sturgeon being taken from Pokegama Lake after a freeze-out in 1926. The fish died because so much snow accumulated on top of the ice that no sunlight could penetrate, thus eliminating the oxygen supply to the fish.

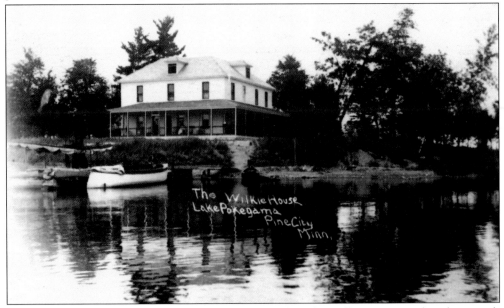

The first resorts were perched on the edge of the lake, like the Wilkie House in this photograph on Pokegama Lake. This 1907 view suggests at least two agreeable options for guests: sun-splashed days of fishing on the lake or leisure-filled afternoons and evenings in a screened-in porch. Besides the Wilkie House (also known as Islandview), the Tuxedo Inn and the Inglenook Inn (owned by J. Adam Bede) were some of the popular resorts in the area. People would come from the Twin Cities or St. Cloud areas by train then ferry out to the various locations.

The city water mains were laid and the water tank completed in August 1913. Municipal water was promoted as a key Pine City feature when it became available.

The Tuxedo Inn resort received its name from the excellence of its carriage trade. Big-city people came for their weekend entertainment. Women in ballroom gowns and men in tuxedos danced to the famous orchestras of their time. The Tuxedo Inn was abandoned sometime between 1913 and 1915, and in 1923 all the remaining items in the house were auctioned off.

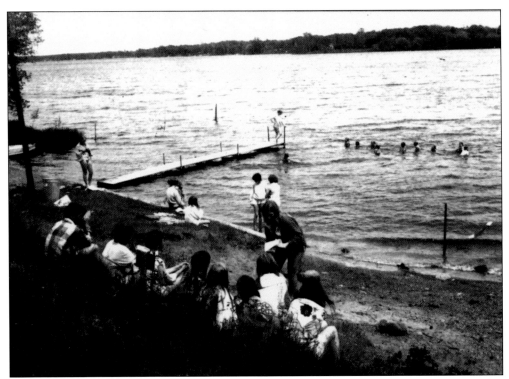

The water has traditionally been a playground for Pine City's residents and visitors. This photograph shows another day at the beach on Cross Lake. Prior to 1916, when the first city sewers were installed, sewage ran into the river and lake, which posed a hazard to health for the swimming beaches.

Soderbeck's ferry was started in 1922 by Magnus Soderbeck and was operated by him and his family for many years. They recognized the need to take people and their vehicles across the St. Croix River, east of Pine City, to Grantsburg, Wisconsin, and vice versa. The first ferry was wide enough to carry two Model T cars or a team and a wagon. In 1927, a larger ferry was constructed to hold four vehicles. (Courtesy of Joyce Lindquist.)

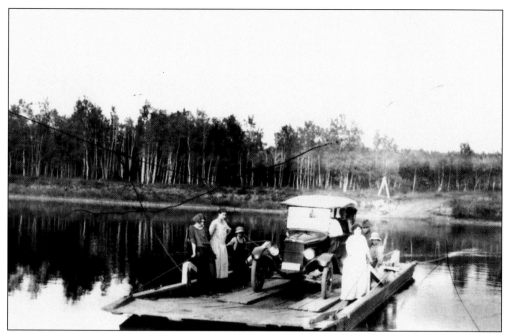

Soderbeck's ferry was also known as the Riverdale Ferry, and it provided transportation across the river for 25¢ per crossing and ran 24 hours a day, May through November. People would pack picnic lunches and spend the day at the ferry. The Soderbecks gave up the ferry in 1942, but it operated under various owners until 1952. (Courtesy of Joyce Lindquist.)

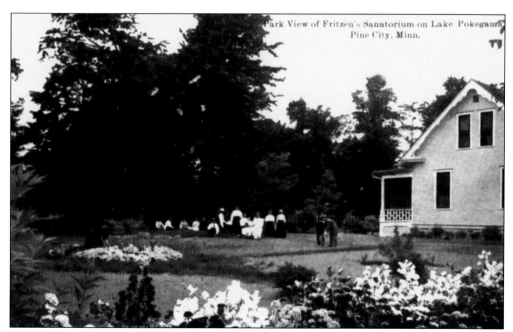

There were two sanitariums for the treatment of tuberculosis, Fritzen's and Pokegama, both on the lake. This is a view of Fritzen's Sanitarium in roughly 1910.

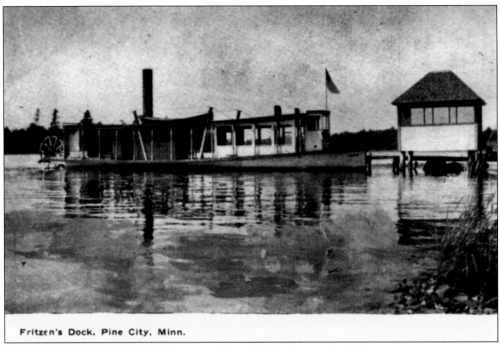

This was the dock at Fritzen's Sanitarium (resort). The boat is the *Fritz* steamer.

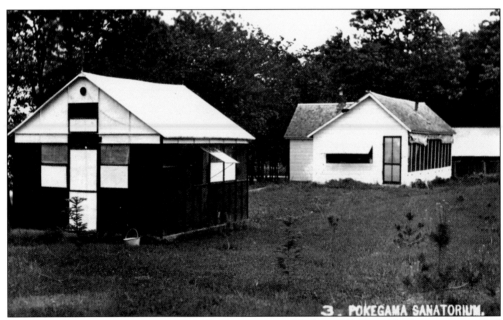

The Pokegama Sanitarium was started by Dr. Lawrence Taylor in 1905 and had an international reputation for its treatment of tuberculosis. By 1910, he had built 15 sleeping cottages and an administration building. There were only three walls on the cottages, with one wall open for fresh air. There was no road out to the sanitarium at this time, so all transport of building materials was conducted via the Snake River. Patients came either to Grasston by rail, then by horse and buggy, or by rail to Pine City, then up the Snake River by steamer.

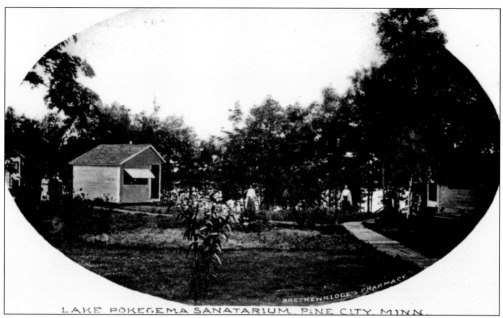

By 1917, the place was pretty self-supporting, with a dairy farm, gardens, apple orchard, and poultry. Staple items such as flour, sugar, and salt were purchased from Twin Cities' warehouses and shipped by rail to Pine City, then to the sanitarium by steamer. The first road came from Grasston, and a road coming from Pine City was not completed until 1919, when Dr. Francis Callahan became the resident doctor at the sanitarium. He was a recognized authority on heart and lung trouble and had given papers before a number of big eastern clinics. He came to the sanitarium after putting in considerable time overseas in the medical department as a heart and lung specialist. He was a graduate of the University of Maryland. He was passionate about his work and believed that medical science would one day control the dread disease of tuberculosis that had cost so many lives each year.

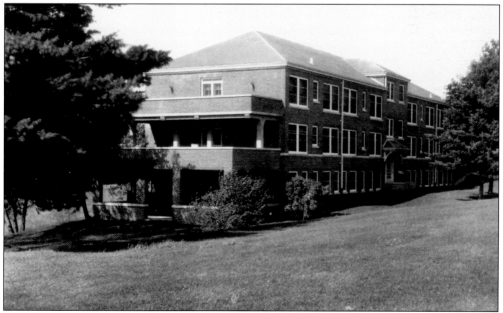

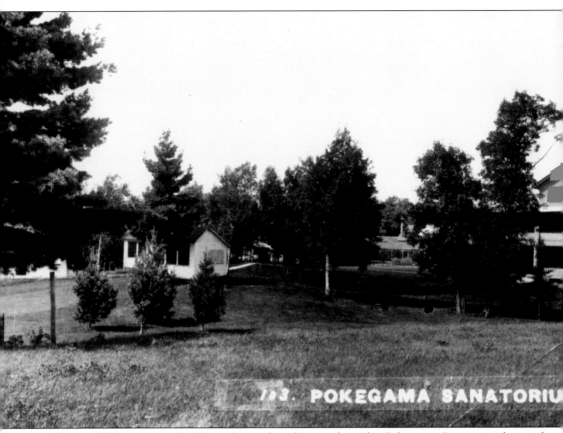

In May 1923, contracts had been let, and work started on the Pokegama Sanitarium hospital, seen partially on the far right of this photograph (and on page 45). The building measured 34 feet by 155 feet, had three stories, and was of fireproof construction at a cost of $75,000. When finally completed, fully equipped, and furnished, it cost an estimated $100,000. It provided the most modern facilities for the treatment of tuberculosis of its kind. It was also set up to perform other emergency medical surgical operations. Terraces for sun treatment were provided at the south end of the building. The first floor consisted of storerooms, linen rooms, laboratories, nurse and doctor offices, and X-ray and operating rooms. The other two floors provided for 22 patients on each floor, with private rooms and two- and four-patient wards. The building was located on the knoll between Dr. Francis Callahan's residence and the administration building. Patients came from all over the world. After the death of Dr. Lawrence Taylor, the doctor who began the sanitarium, the hospital deteriorated and was finally closed in 1943.

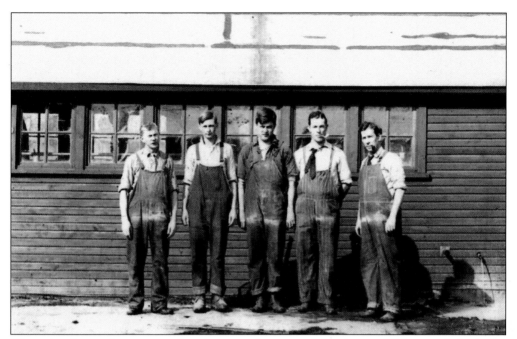

Clamming for pearls was more than just a pastime around the shores of Pokegama Lake in the early 1900s. This photograph is thought to have been taken in 1910 at Pine City's button factory. The others are not identified, but Fred Cutler is the man on the right. Notice the polisher or grinder marks on their overalls. The tool for cutting the buttons was said to be about the size of a pencil, and the cutter had to fashion a set of saw teeth into the steel. (Courtesy of Scott Cummings.)

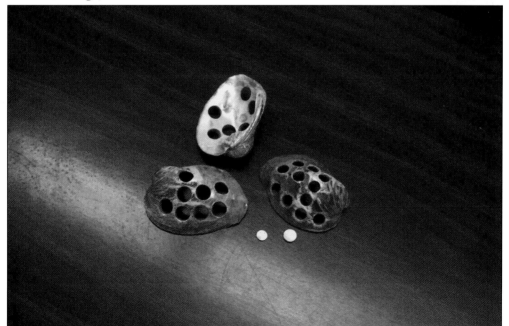

This photograph shows some Pokegama Lake clamshells that were found long after they were punched. The blanks were sent to Japan to be polished and finished. (Author's collection.)

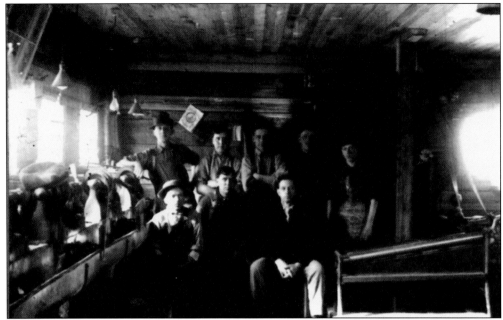

This photograph shows inside the button factory, owned by J. J. Madden. At that time, all buttons were made from pearl or bone, and the local factories (the Madden factory as well as Melvin J. Cherrier's home-based business) cut blanks from shells. An average half shell produced 8 to 10 blanks. It was an industry that peaked and plummeted locally within a two-year span. Despite efforts to restock the lake, the industry died out.

John Norstrom, pictured here with his wife, found a pearl in the era of the Pine City button factory that was worth enough to purchase a new car. According to tales, another pearl was found by a different clammer that netted $3,000. A house was built with the proceeds of the sale.

Three
STREET SCENES AND AERIAL VIEWS

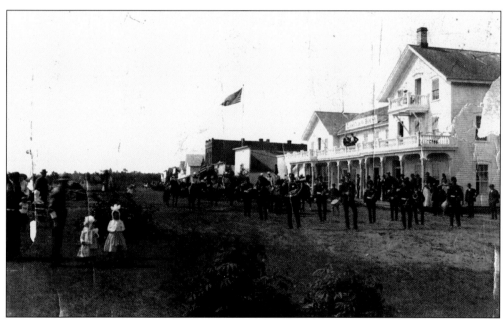

Albert Pennington, a pioneer resident of Pine City, purchased the north half of the block where First Avenue Southeast meets Fifth Street Southeast. He went into the hotel business with A. L. Conger, opening the Lakeview House hotel, at the forefront of this 1888 photograph. It was taken after a local band had just completed its appearance in a summer parade. The brick building beyond the flag later became the Agnes Hotel. (Courtesy of Marina Vork.)

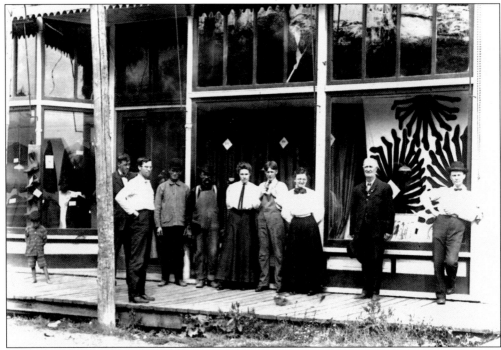

This photograph of the Pine City Mercantile was taken about 1915. The gentleman on the right is Albert Houdek, who worked there his whole life and slept there as a watchman. The second man from the left is Roy Carlson, who owned the store. One of the two men to the right of Carlson is Pete Holm, and the young boy is believed to be William Houdek. The "Merc," as it was called, began business on December 1, 1900, and was purchased by Carlson in 1908. It sold everything from groceries to dry goods to clothing. Carlson's son Bob took over in 1945 and ran the store until 1978. It was located along Second Avenue Southeast.

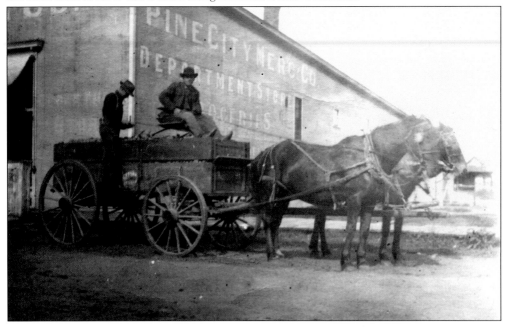

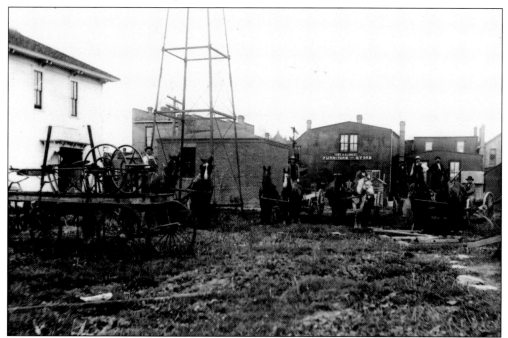
This photograph depicts the means by which several arrived at work downtown in the earliest days, by teams of horses. (Courtesy of Mike Sauser.)

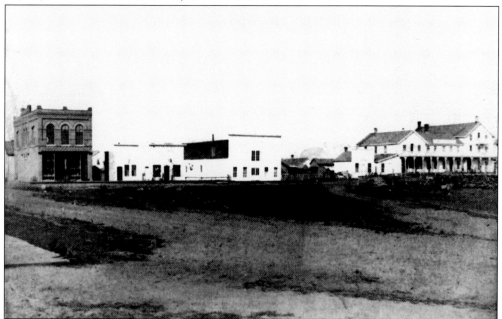
This photograph, taken in 1888, shows a part of Pine City's then main street. The photographer stood on the northeast corner of Robinson Park and faced northwest. The building on the left was part of what became the Agnes Hotel (and the Hurley Saloon), and the large white structure on the right was the Lakeview House, a hotel, and Pennington store. To the south of the Lakeview House were the post office, the skating rink, Muter's Tin Shop, and Murray's Barbershop. (Courtesy of Marina Vork.)

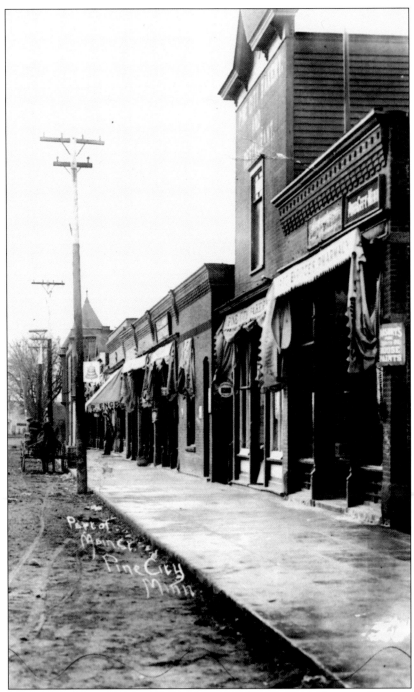

This street scene shows a one-block portion of the old Main Street, looking south, complete with a pharmacy, bakery, restaurant, bank, and more. The First State Bank of Pine City, midblock, began with $10,000 of capital stock. In 1920, the First National Bank formed; the bank's steady growth was reflective of the community in which it served. The early bank officers can be credited with helping to establish the dairying industry here since thoroughbred dairy animals were brought in by them.

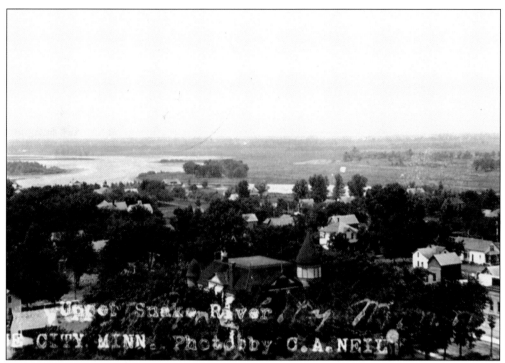

Pine County's second courthouse appears in the forefront of this aerial view. When Pine City became a center for county business, more stores, saloons, and banks set up to satisfy the needs of the area residents.

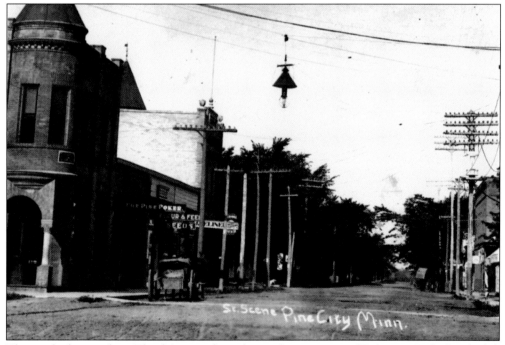

This is a look west along Third Avenue from the southwest corner of Robinson Park. On the left is the Rybak Building, home to the *Pine Poker* and a law office at the time.

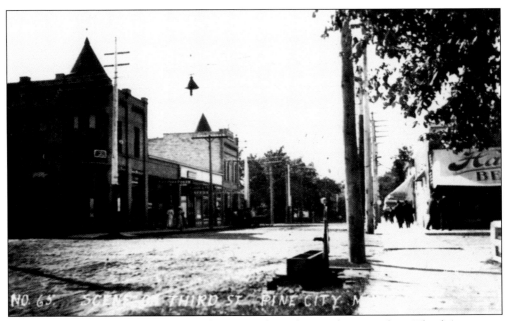
Notice the hitching post in front of Robinson Park on this similar view along Third Avenue.

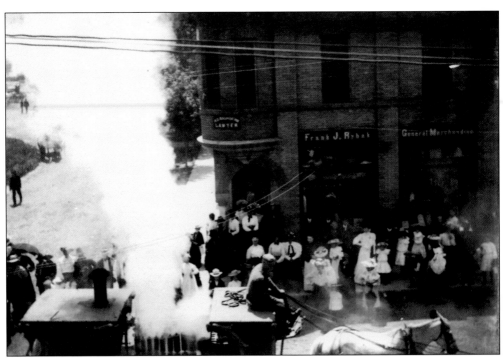
A parade is en route in this photograph, facing south toward the Rybak Building, home at the time to a general merchandising store and R. C. Saunders's law office.

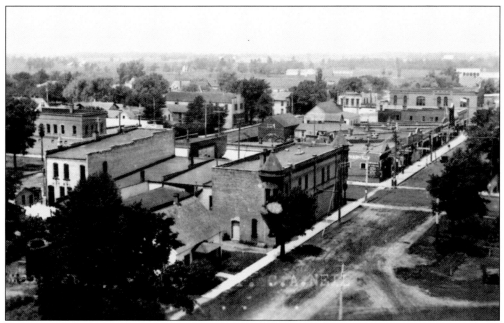

This photograph looks over downtown Pine City, toward the northwest, with the Rybak Building in the center. South of that building is the Brandes home, Pine City's first home.

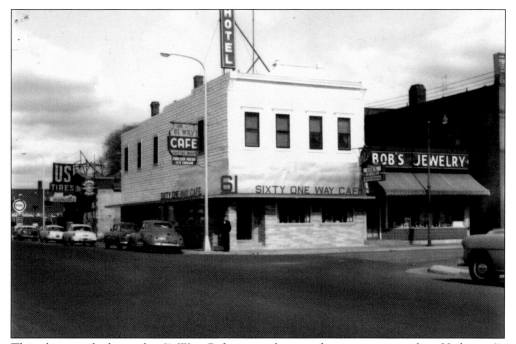

This photograph shows the 61 Way Cafe, a popular stop for motorists traveling Highway 61. It also served as the Greyhound bus stop for a time. In the background is a sign for the Agnes Hotel, which can be seen on the far right. (Courtesy of Bob Thiry.)

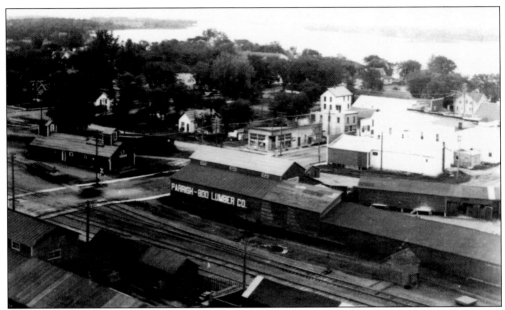

This is an early aerial view of the railroad in downtown Pine City, looking northwesterly. Businesses in Pine City's earliest days included shingle mills and sawmills. From the period between 1871 and 1909, there were several of them, including the J. S. Ferson Mill, W. E. Jones Mill, Dominish Mill, Heath Company Mill, and Burgher Brothers Mill. Other early businesses included two banks, a brewery, a flour mill, a brickyard, an electric light plant, a creamery, and an opera house.

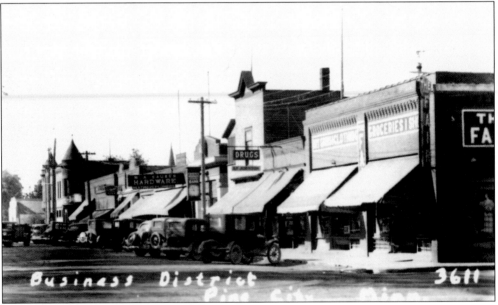

By the time of this photograph, Pine City was establishing itself as a full-service community. It was home to a law office, physician, feed store, grocery store, blacksmith, shoe dealer, barber, insurance agent, realtor, drugstore, laundry, general store, livery, milliner, meat market, furniture dealer, tailor, hardware store, several saloons, and five potato warehouses. The community boasted 1,500 residents.

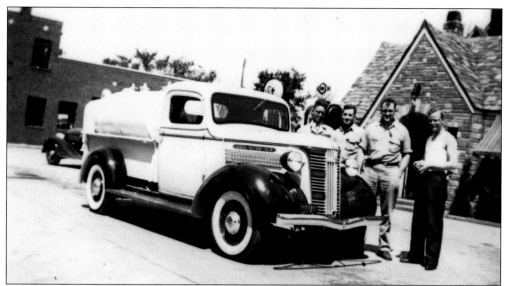

In the building on the right was a fueling station constructed in 1932. Originally, it was a DX station, and it also became a Pure station. It was built and owned by Ike Gillespie. Gillespie also owned the General Motors dealership next door. For a time, it was the only 24-hour station between the Twin Cities and Duluth. During the late 1930s and early 1940s, letters could be sent out of town via this location. The constable, Art Friend, would pick up the mail and take it to the train depot. In those days, mail was sorted on the mail car. From 1957 to 1960, Warren Davis ran the station. The station closed in the early 1960s. On the left is Coca-Cola Bottling. Albert Nelson and his three sons, Vern, Art, and Edmund, bought out the Coca-Cola business in October 1926. They used the original old frame building until 1936, at which time the building was razed and a new brick building was constructed. In 1948, an addition was put on to accommodate additional business and for storage. In 1949, they installed more modernized bottling equipment. (Courtesy of Scott Cummings.)

This photograph shows Clark Pennington's new Buick Special Series 40 sport coupe in the summer of 1936 at the fueling station. (Courtesy of Scott Cummings.)

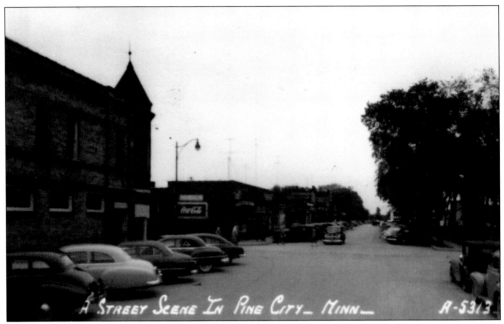

This view is looking north along the west side of Wiseman and Robinson Parks. On the left is the Rybak Building. Downtown Pine City has seen much activity throughout its history.

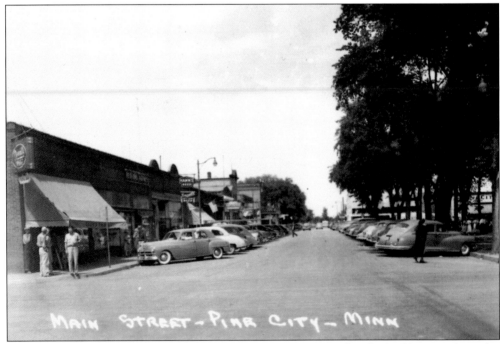

This view also looks north, along the west side of Robinson Park. The building on the right, north of the park, was the Pine City Mercantile.

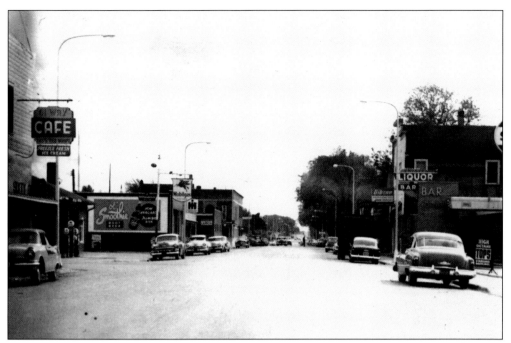

This view looks south on Highway 61, with the 61 Way Cafe on the left and a Standard station and the municipal liquor store and bar on the right. The billboard south of the café highlights jumbo-size Ol' Smoothie. At one time, the Pine City Coca-Cola bottling plant turned out Ol' Smoothie root beer, as well as Coca-Cola, 7Up, and orange, grape, strawberry, black cherry, and cream sodas.

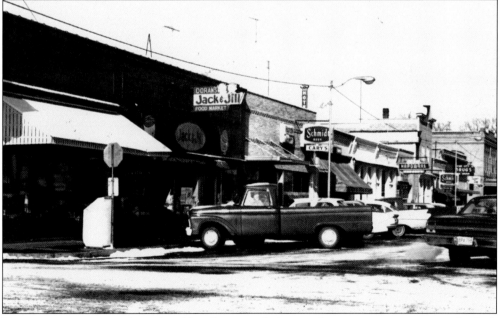

From corner to corner along the old main street, facing northwest, are a corner store, the Jack and Jill food market, Cary's tavern, a shoe store, Sauser's Hardware, another tavern, Pine City Drugs (and ice cream), another shop, and the Agnes Hotel across the street.

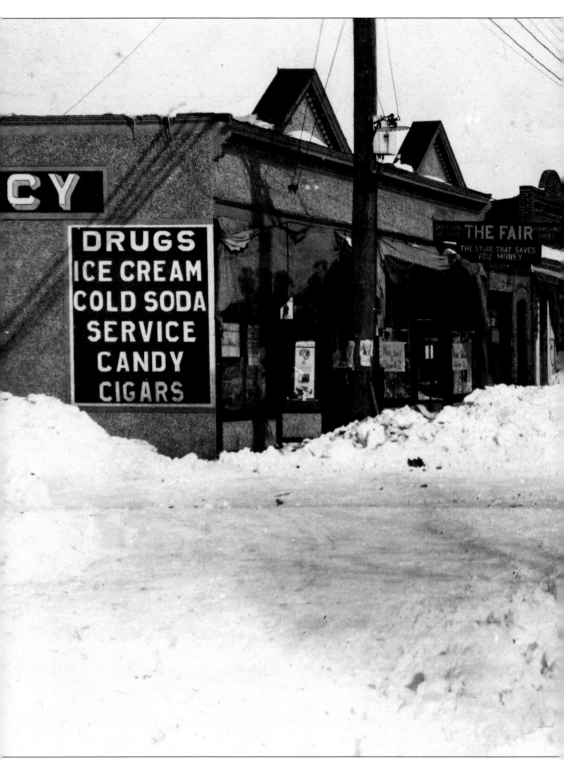

On this March day in 1922, much of downtown is blanketed in snow. Streets are impassible, and it appears few ventured out. Snow clearing was done in several parts then, and much of

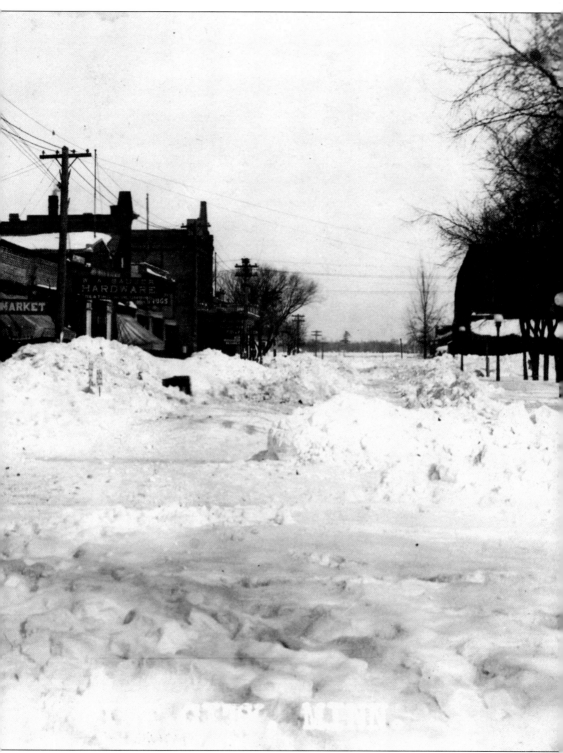
the town shut down in such conditions. On the south end of the block were a pharmacy and a soda fountain.

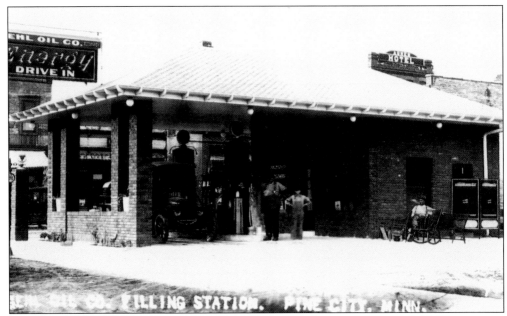

On a Saturday evening in May 1923, the lights were turned on, and the new Gehl filling station opened for business. The new station was the most up-to-date service and best service station between St. Paul and Duluth. It was equipped with restrooms for both men and women, the roof extended over the double driveway, with two of the latest air-operated gas pumps and lubricating oil pumps in the center.

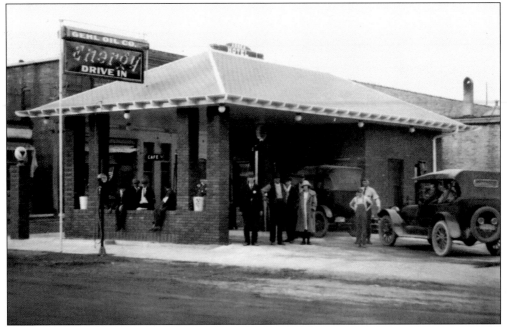

The Agnes Hotel peaks over the top of the building in this photograph. Free air and water stations were located on the west and north sides of the station. A large electronic sign extended over the sidewalk on the highway, and a public drinking fountain was located on the wall on the highway sidewalk. Gehl first came to Pine City in 1900.

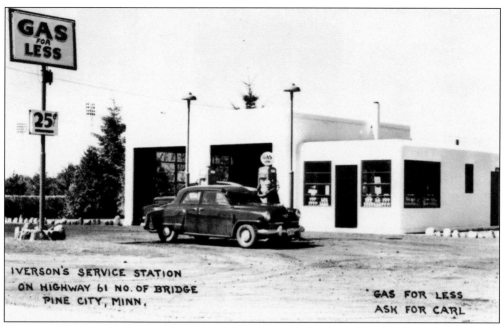

The site of the Carl E. Iverson service station later became the Tasty Freeze, then was demolished. It was located next to the Streamliner and the American Legion post.

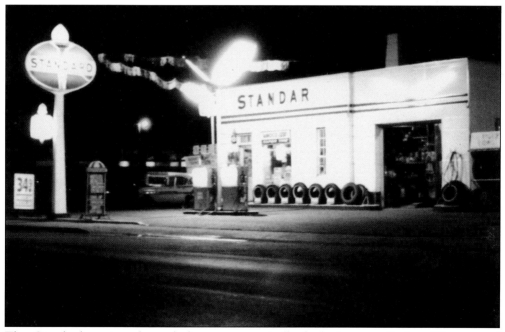

The Standard station, located downtown, typically had tires on display. (Courtesy of Jennie Olson.)

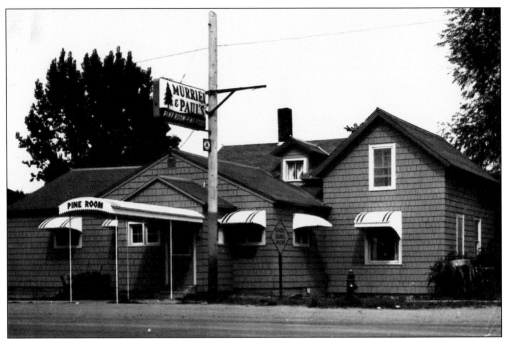

Paul and Murriel Miller bought the Buirge Tea Room along Highway 61 and ran it for about 25 years as Murriel and Paul's Pine Room. It was Pine City's finest dining establishment. Paul traveled to the Twin Cities to get sirloin twice a week, brought it back, and stripped the fat off it. Murriel baked, washed, and starched napkins and did all the things it took to make it a AAA-rated restaurant and to place Pine City on the map. (Courtesy of Carolyn Miller.)

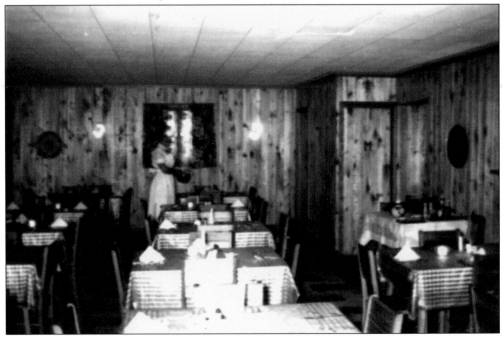

The music and ambiance were second to none inside Murriel and Paul's. It was not just a place to eat; it was an experience. (Courtesy of Carolyn Miller.)

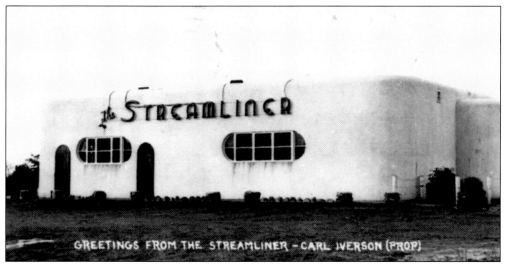

The Streamliner, later Scotty's Streamliner, was built and owned by Carl E. Iverson, and it was advertised as a place for steaks, seafood, chicken, banquets, and parties. This is a 1944 photograph. The establishment was open 5:00 p.m. to 1:00 a.m. on weekdays and 1:00 p.m. to 1:00 a.m. on Saturdays and Sundays. It was one of a few dance halls in the Pine City area. Pine Camp was purchased by Ray and Phil Salonek in 1946 from George Smith. The Saloneks moved to Pine City from Minneapolis to take over the ballroom, which was not being used as such at the time. Pine Camp featured three tiny resort cabins in addition to the dance hall, and the Saloneks added two more cabins to make five. Several big-name bands played there. In the 1960s, Pine Camp received a new look. They added on a big addition, the Rose Ballroom, to make it the biggest entertainment complex in the country. Despite, or perhaps because of, the reputation that the ballroom had, there was free use of the hall for wedding dances and parties.

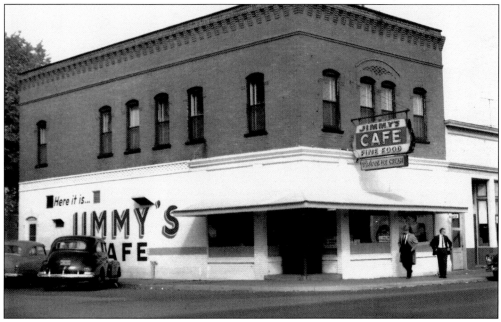

This building, once home to Jimmy's Cafe, has been home to a corner café ever since. (Courtesy of Bob Thiry.)

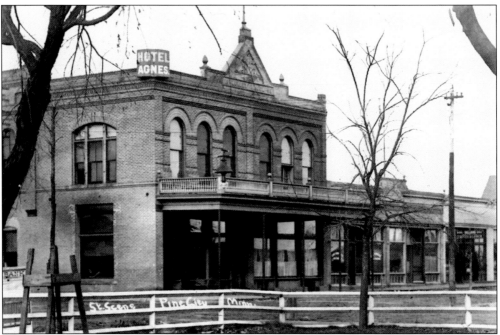

Hotels were established as some of the earliest businesses in Pine City. They housed workers in the lumbering trade and from the railroad. The Bracket House and the Pine City House were two of the earliest hotels. The Agnes came later. In the July 11, 1974, *Pioneer*, the community learned that the Agnes Hotel would be auctioned at a sheriff's sale. Richard Viets, editor of *Pioneer* back then, wrote, "Let's hope the old brick structure will finally be demolished." That is precisely what happened.

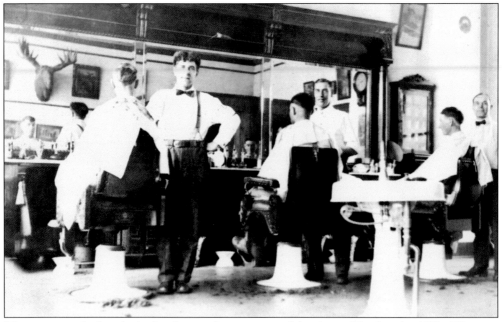

These men worked in the barbershop in the west part of the Agnes Hotel in the 1930s. The part of the shop at the right was devoted to a beauty parlor. (Courtesy of Joyce Lindquist.)

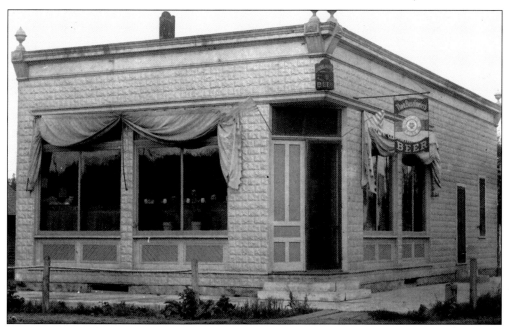

This photograph depicts the first tavern in Pine City, which served Buselmeier Beer, a local brew. Rudolph and Amelia Buselmeier came to this country from Germany in 1878 and started a brewery here. The brewery was doing well when Rudolph died. Amelia then ran the business successfully for several years and married Rudolph's brother Theodore. The brewery complex grew to be large, but by 1979, only the icehouse remained. After the brewery closed, the Nethercott Hospital utilized the brewery buildings.

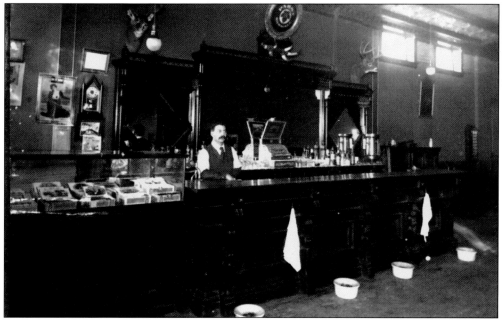

This photograph shows the interior of an early tavern run by Emil Hoefler. Deer mounts were common in the interior of Pine City's businesses from early times to present. (Courtesy of Central Minnesota Coin and Antiques.)

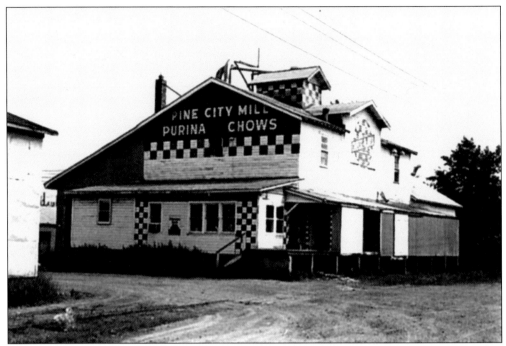

This is a past photograph of the Pine City Mill, along Third Avenue Southeast, in 1974. Another feed store operation, along Railroad Street, was known as the Farmers' Exchange in the 1930s.

This is a 1912 photograph of the front of Sauser's Hardware, downtown Pine City. The store has been Sauser's since 1909 and a hardware store since 1880. There was a tavern to the south, which William A. Sauser purchased after World War I and incorporated into their store. In addition to hardware, the store used to carry fine watches, jewelry (including wedding rings), and silverware.

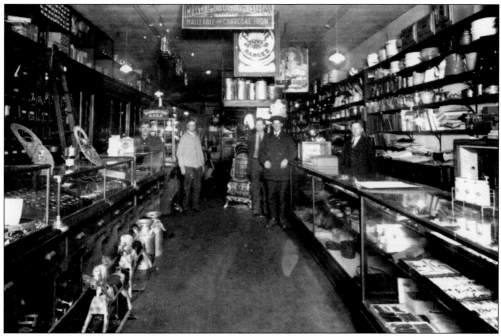
This photograph shows an early interior view of Sauser's Hardware. William A. Sauser (far right) bought the store in 1909. (Courtesy of Mike Sauser.)

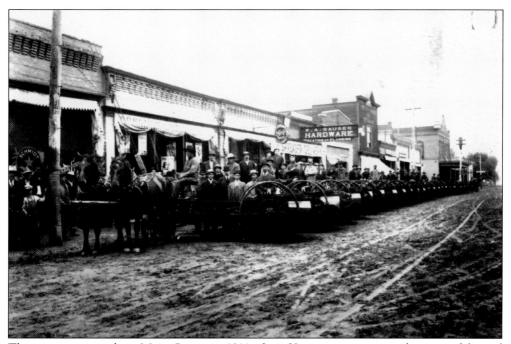
This scene appeared on Main Street in 1914 when 32 new manure spreaders were delivered to Sauser's Hardware. All had been sold in advance in a big spreader promotion. (Courtesy of Mike Sauser.)

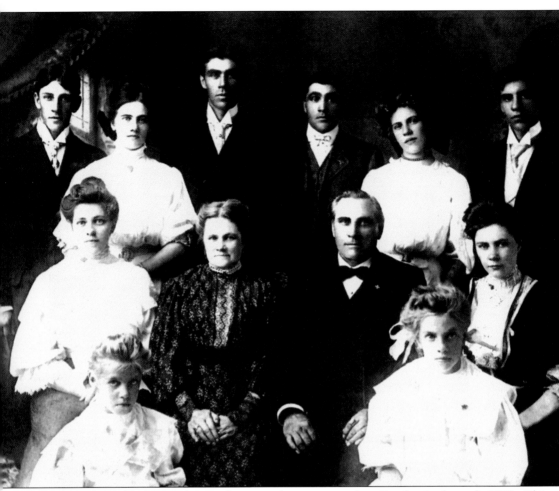

The Isak Wickstrom family joined a wave of immigration from Sweden in the early 1900s. This picture shows the family after their arrival in Pine City in 1906. According to the *Pine Poker*, "The trip was made in three weeks, which is considered wonderfully fast time." Isak continued working in his trade of shoemaking. Hugo worked for the local telephone company. August bought a farm on the west side of Cross Lake. Hulda and her husband operated a general mercantile in town called Asplund Grocery. Alma and Henry Buirge owned and operated the Buirge Tea Room on Highway 61. Bror worked as a bank janitor and ended up becoming president of the Ladysmith, Wisconsin, bank. John was a tailor by trade and died at 24 from tuberculosis. Hanna married a stonecutter from Sandstone. Beda married a local contractor named Oscar Larson who built the first Pine City armory. Hildur passed away at the age of 20 from tuberculosis. Anna Victoria and her husband joined a religious cult headed by Father Divine, an African American man who claimed to be God. Anna's family never saw or heard from her again. (Courtesy of Alaina Lyseth.)

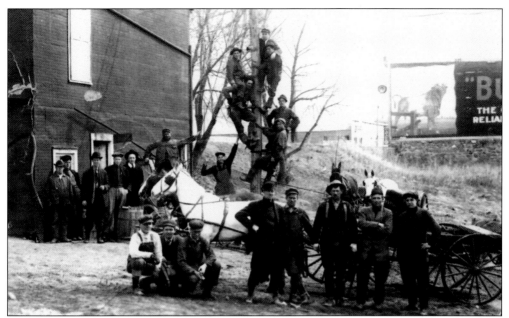

In November 1899, Charles Avery of North Branch, manager of the Northwestern Telephone Company, was in the village and while here placed a telephone in the courthouse and rented the room in the rear of the Conner Saloon for a central office. As soon as poles and wire arrived, a local exchange began to be put in place. The first telephones were installed in the village in 1900 by the Minnesota Mutual Company, which had headquarters in North Branch. This photograph shows some men on one of the first telephone poles. In 1918, Northwestern Bell Company took over. Rates were $1.50 per month for a business place.

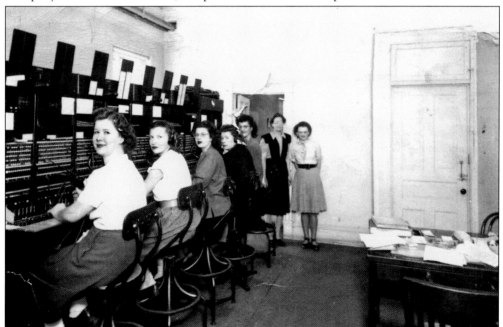

This shows some early Pine City operators. Maggie Payne was the first operator. (Courtesy of Marion Larson.)

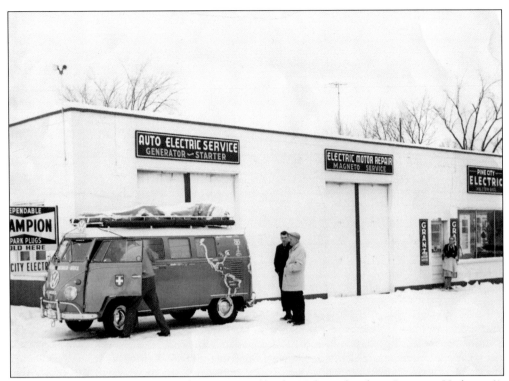

This photograph shows Pine City Electric, owned by the Holstein brothers. It was on Highway 61, which incidentally was one of the main north–south thoroughfares in the United States prior to the development of the interstate highway system. For that reason, Pine City's portion of the highway has been home to many automobile-oriented businesses, such as this repair shop and, earlier, the fueling station shown below. (Below, courtesy of Jennie Olson.)

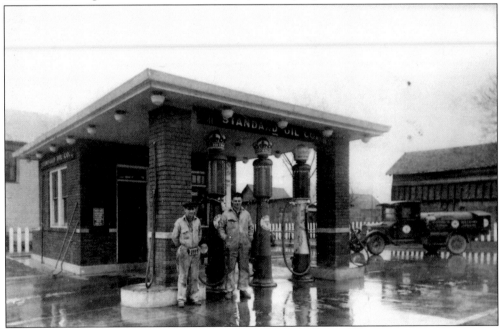

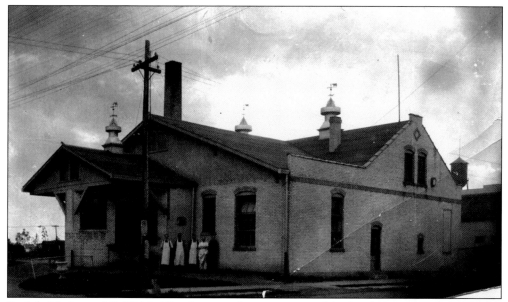

Fred A. Hodge and P. W. McAllen became the proprietors of the local creamery, shown in this photograph, at a time when it was running at a loss. They are credited for retaining it in the community and getting it profitable again. At one time, they were receiving 4,500 pounds of milk per day. The two men opened a new plant on the west end of town on land donated by A. M. Challeen. Hodge was born in Francestown, New Hampshire, in 1854 and came to Pine City in 1877. He was elected Pine County auditor and later became interested in property in Pine County and Pine City, for which he became noted as an important businessperson in Pine City's progress. He was president of the First State Bank of Pine City in its first years. A Republican, he served in the state senate from 1894 to 1898.

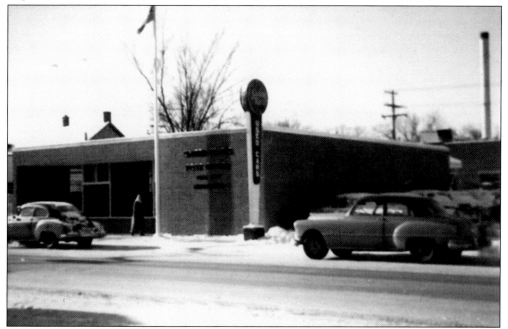

Pine City's modern post office is seen here in 1965. (Courtesy of David Hill.)

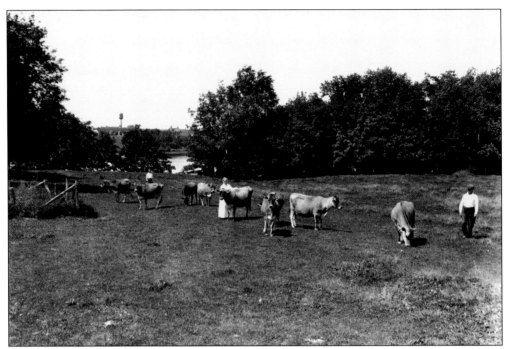

After the logging industry subsided, the railroad began to campaign for settlers in the region by encouraging them to farm the region on cheap, rich land. Many Czechs and Bohemians responded to the call. A Sokol camp (shown below in 1926) was even erected in 1926 near Pine City. By 1945, there were about 3,000 farms averaging 130 acres apiece. The largest enterprise was dairying (butter and dried milks were the main products). Chief crops were hay, oats, and some corn. The photograph above from 1920 shows the Striegl Farm looking toward Pine City with the old water tower in the background and some Guernsey cows in the foreground. City water was installed in 1913. (Above, author's collection.)

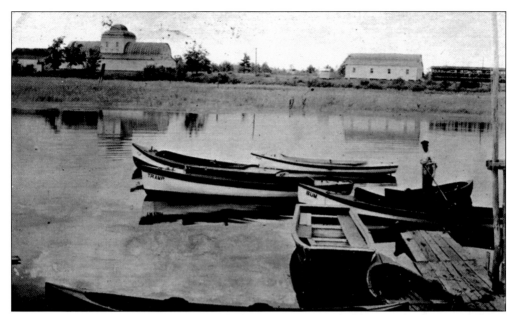
This photograph is of the Snake River looking north toward the Pine County Agricultural Society's fairgrounds and accompanying buildings.

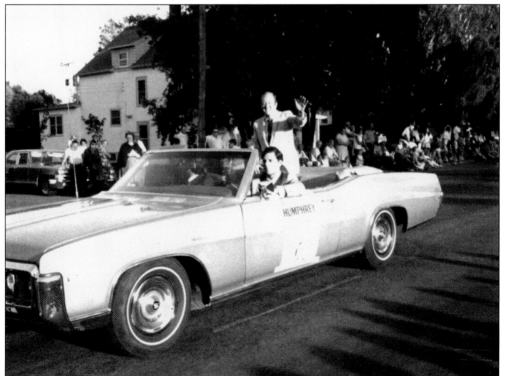
The chamber of commerce has sponsored a parade over the years to take place the weekend of the Pine County Fair. Pictured riding through this parade, on the back of the convertible, is Hubert H. Humphrey Jr., who twice served as a U.S. senator for Minnesota and was the 38th vice president of the United States under Pres. Lyndon B. Johnson.

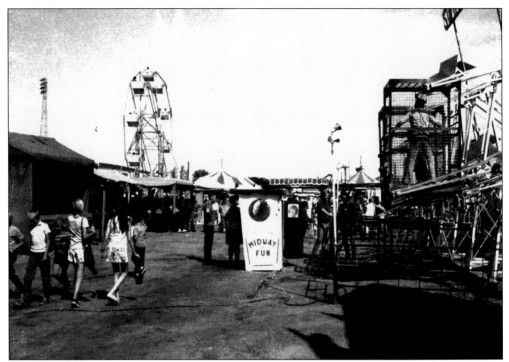

The Pine County Agricultural Society sponsors the Pine County Fair, the largest annual event in Pine City. Some 30,000 people attend the fair, which has had free gate admission since its inception. The demolition derby is the largest grandstand draw.

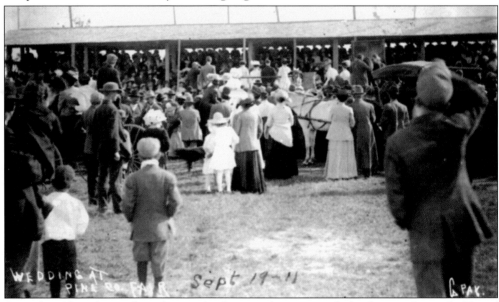

Several weddings have taken place at the fair over the years, with the first one being the Eaten/Wood wedding. Dozens of class reunions have been held in conjunction with the fair since a large number of Pine City High School graduates are back anyway. This shows a photograph at the Pine County Fair of a wedding that took place in 1911. In the 1940s and 1950s, Pine City became known as a "quickie marriage mill."

This image is of James Engel, one of Pine City's early postal workers. Hiram Bracket was Pine City's first postmaster. An office holder and a businessman in Pine City, Hiram Bracket was born in China, Maine, in 1817; he came to Pine City in 1868 and built a hotel, the Bracket House. He died in 1883.

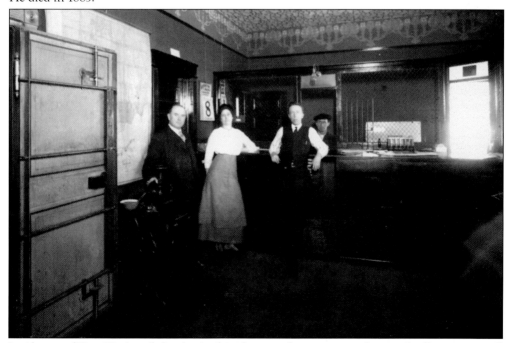

Inside one of Pine City's early banks, in this photograph one can see the caged teller area, as well as the door to the vault, in the front left.

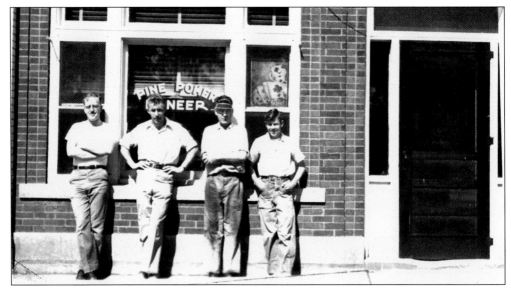

Pine City's first newspaper, the *Pine County News*, ran from 1874 to 1877. The *Pine County Pioneer* and *Pine County Record* also ran leading up to the 20th century. J. Adam Bede started a two-page magazine-size newspaper titled *Bede's Budget*, which ran from 1897 to 1900 and contained political advertising, poems, and jokes. It was converted to the *Pine Poker* because Bede said he wanted to use it occasionally to prod into the conscience of the community. In 1939, the two community newspapers, the *Pioneer* and the *Poker*, merged into the *Pine Poker-Pioneer* (as shown in this photograph) under the ownership of W. S. McEachern and D. R. Wilcox. That office is pictured here with four unknown gentlemen outside. Since the late 1960s, the community newspaper has been called the *Pine City Pioneer*.

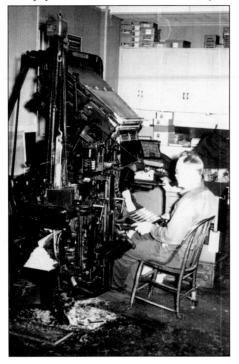

This photograph shows a historical look inside the local newspaper office and the printing technology of the day. (Courtesy of Jennifer Rydberg.)

A bunch of children gather in Robinson Park, downtown Pine City. The park's name stems from Richard G. Robinson, mayor of Pine City from 1895 to 1897. Robinson was born in Jackson County, Iowa, in 1829. He came to St. Croix Falls in 1848 where he was involved in lumbering, surveying, and exploring. Robinson was appointed land examiner for the Lake Superior and Mississippi Railroad in 1872 and remained in Pine County until after that time. Robinson donated land for the park that bears his name.

The drum and bugle corps (dressed as Native Americans) marches on the street alongside Robinson Park and Wiseman Park. (Courtesy of Bob Thiry.)

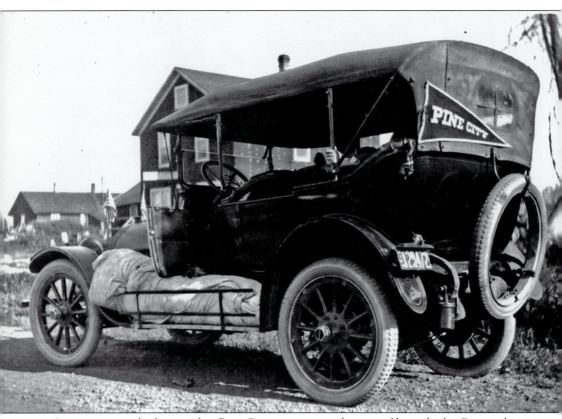
A motorist travels about with a Pine City pennant on the rear of his vehicle. Cars at this time had no trunks, so to carry camping items or clothing, items were carried on the side of the car or tied to the back. (Courtesy of Joyce Lindquist.)

Four

A WAY OF LIFE IN PINE SOCIETY

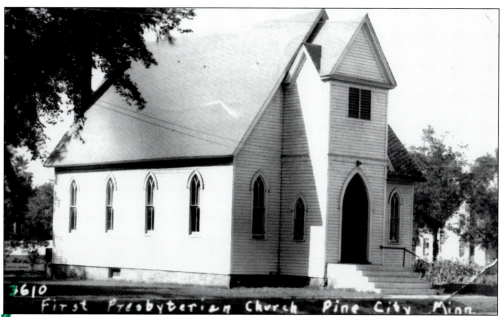

The First Presbyterian Church was organized in 1870 and Rev. D. C. Lyon was its first leader. Charter members included Anna Bryon, Sarah King, Augusta Ferson, and Ida Person. This was the first church to organize in Pine County. The first building was erected in 1878 and is still part of the building that was remodeled in 1949. Visiting ministers conducted services over 20 years, until 1894, when the first pastor was installed, Rev. P. Knutson.

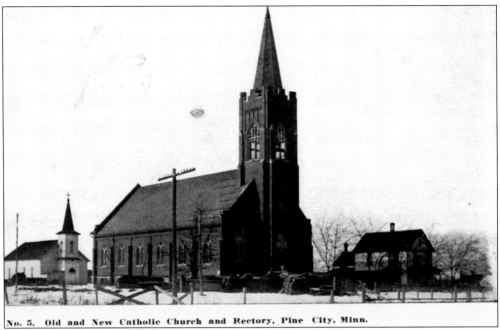

The first Catholic priest to visit the area was Fr. Maurice Murphy in 1871; a congregation was organized the next year. Services were held in the railroad section house and in private homes. The first Immaculate Conception Catholic Church was constructed in 1879 (shown on the left). The first resident pastor was Fr. Sebastian Schels, who moved into the new church residence in 1895. A four-room parish school was built in 1956; that first year, there were 127 students.

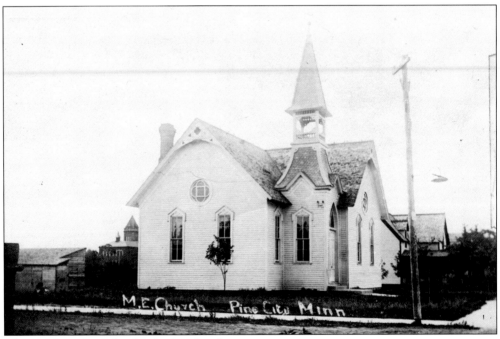

This was Pine City's first Methodist church.

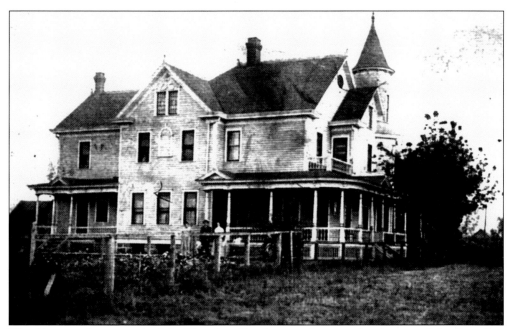

This Victorian house was built by Theodore Buselmeier, who owned and operated the Pine City Brewery. According to records, the house was built in 1901–1902 for $5,000. It later became Lakeside Memorial Hospital.

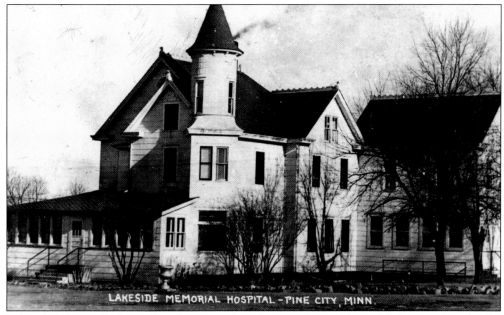

Lakeside Memorial Hospital is shown in this photograph. Dr. Ernest Nethercott bought the hospital and 15 beds were made available. It was the only complete hospital between Moose Lake and St. Paul. Another beloved doctor of Pine City's past was Dr. Alf K. Stratte, who had his office in the south end of the Rybak Building.

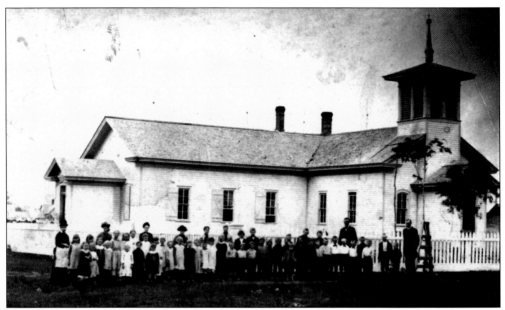

School District No. 3 was organized sometime before 1871; the school was built downtown and served as the social center of the village, like a modern-day community center, as well as a church and Sunday school building. Events that were held there included spelling bees and song fests. This photograph was taken in the 1890s. Susan Shearer is one of the teachers standing among the students. When the school was vacated, it was moved to the fairgrounds to be used for 4-H Club activities. The wood-frame schoolhouse was replaced by the Webster School in 1903. On June 1, 1903, the first graduating class was presented in the opera house. Graduating were May Pennington, James "Ben" Hurley, Martin Hurley, Anna M. Voss, Marie Kibler, and Jessamine Allen.

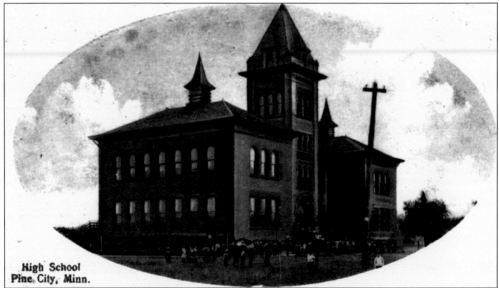

The second school in Pine City, after School District No. 3, was the Webster School, a beautifully designed large brick structure. The two wings that can be seen were added in 1903 to increase the school's size. Pine County's first high school was established in the Webster School in 1904.

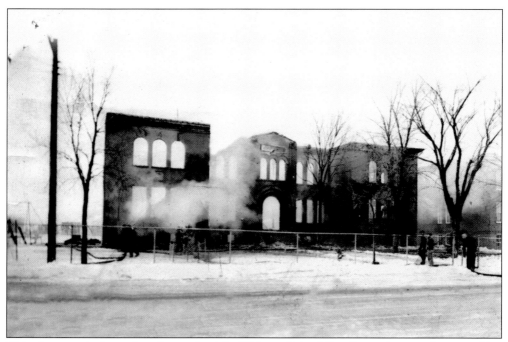

This photograph shows the aftermath of the Webster School fire. Bystanders watch it smoulder. The architectural gem was completely destroyed.

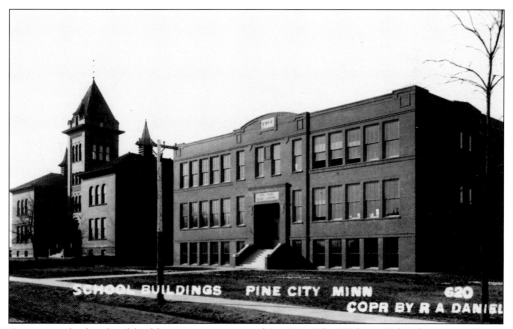

A separate high school building was constructed in 1914. The Webster School was completely destroyed by fire on January 12, 1939.

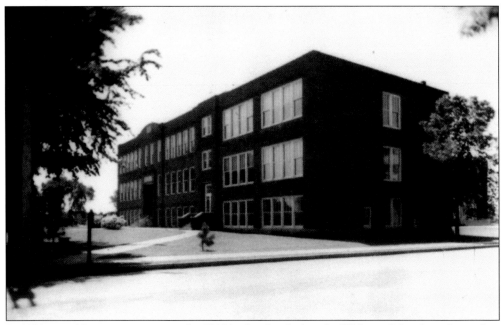

In 1938, an addition was put onto the 1914 high school after the Webster School was burned.

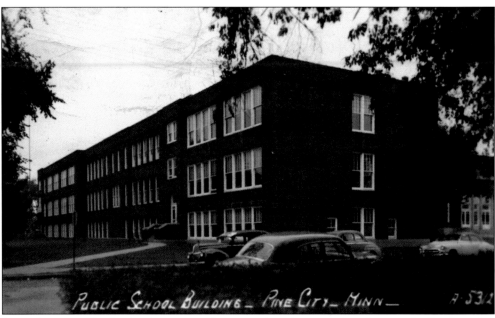

Later the original high school was partially removed, as shown in this photograph. On the right, the auditorium shows.

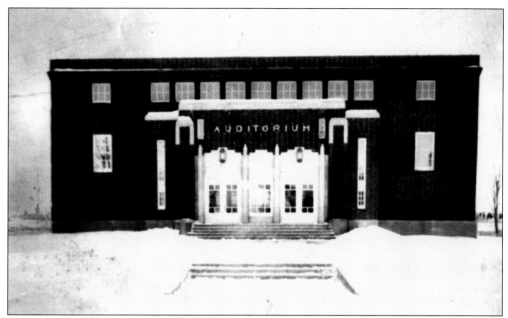

The addition that was put onto the first high school was completed the same year as this splendid auditorium, 1938. The auditorium stood independent of the rest of the school campus when it was first constructed.

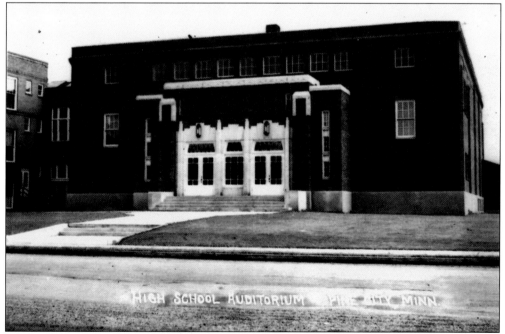

The auditorium was eventually tied into the rest of the school complex. It was the finest venue in the region for shows, events, basketball games, concerts, and conventions. The State Firefighters Convention was among the events held here, bringing hundreds of firefighters to town in the 1920s. The auditorium seats 600. This photograph was taken in 1944.

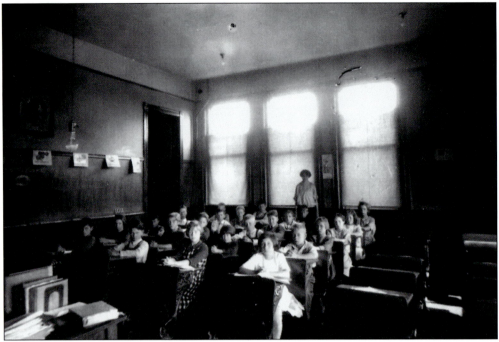
An early Pine City schoolroom is shown in this photograph.

This image shows some early faculty at Pine City High School. (Courtesy of Marion Lones.)

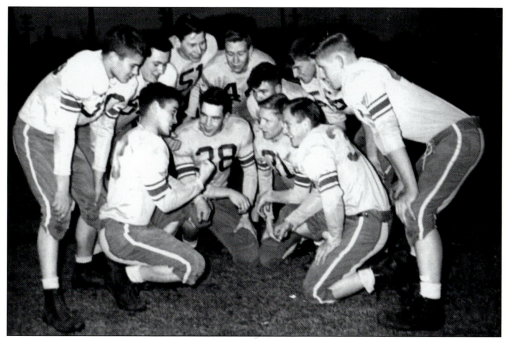

In this photograph is the 1952 Pine City High School Dragons football team. Huddled together are, from left to right, (first row) Dick Thiry, Ron Spickler, Ed Gillespie, and Ben Kozak; (second row) Jon Stratte, Bob Salonek, Joe Holetz, Jack Anderson, Arden Hippen, Dick Luedtke, and Henry Korf. The coaches were Les Nell and George Saunders. The football field was lit for the first time in 1948 for evening games. Saunders Field, for track and football, was named after George Saunders and came to be in 1976.

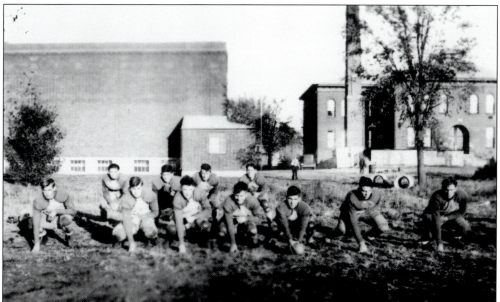

This is the 1937 football team. From left to right are (first row) Clark Foster, Lester Korsch, Cliff Perkins, Warren Glade, Bob Dixon, Dave Hoagland, and Irwin Blanchard; (second row) John Sauser, Jack McKusick, Stan Greenley, and ? McNeil. (Courtesy of Clark Foster.)

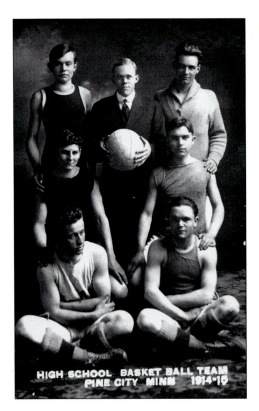

In this photograph is Pine City's very first basketball squad in 1914–1915 (names unknown). (Courtesy of Central Minnesota Coin and Antiques.)

This photograph shows the district champion Dragons basketball team of 1917–1918. This postcard was sent from E. J. P., of Hopkins, in 1954 for 2¢. It reads, "Jim you were a mighty fine looking athlete in 1917," referring to Dragons athlete Jim Engel. In 1980, Pine City also had a district champion basketball team. (Courtesy of Central Minnesota Coin and Antiques.)

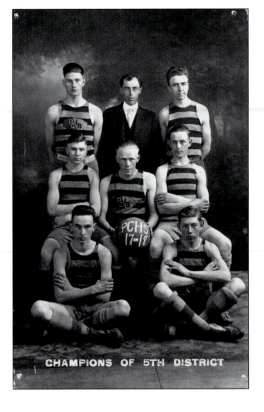

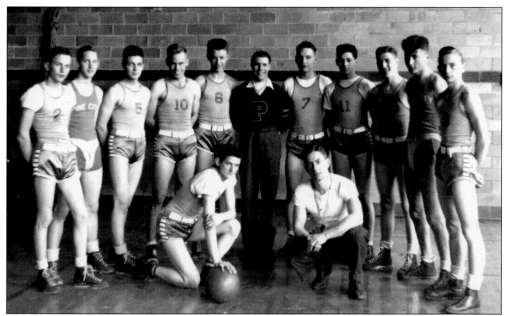

Included in this basketball photograph are, from left to right, (first row) Jack McKusick and coach George Saunders (who taught in Pine City schools from 1937 to 1978); (second row) Sandy McKusick, Ben Boo, Albert Kyncl, Clark Foster, Tom Gardner, John Roberts, Robert Wilson, Albert Milgram, unidentified, Leonard Silesky, and John Lindquist. In 1937, the school district employed 31 faculty members between the elementary and secondary schools, plus a superintendent and principal. The only single man on the faculty, Saunders, was paid $110 per month to teach. He also was the scoutmaster, assistant football and basketball coach, and the head track coach. And, being the only single man on the faculty, he chaperoned the parties and dances. (Courtesy of Sandy McKusick.)

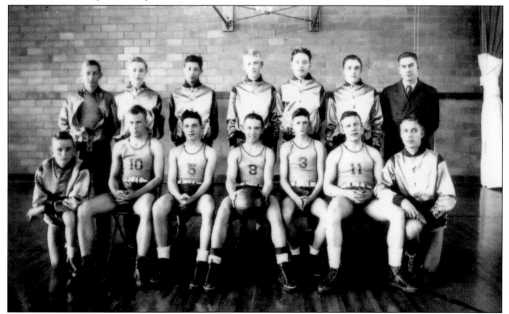

This is the 1938–1939 basketball team. (Courtesy of Clark Foster.)

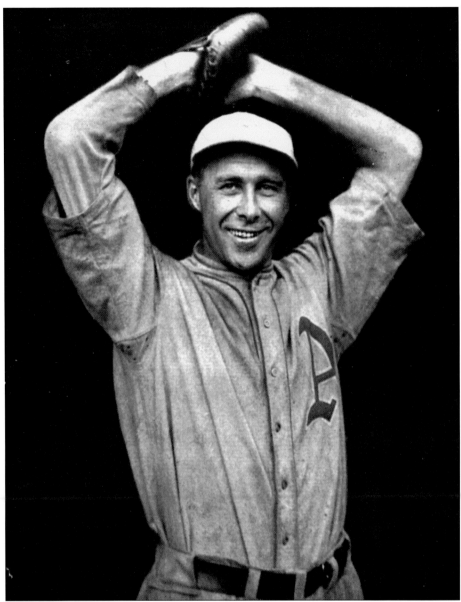

One of baseball's finest performers, Rube Walberg, was born George Elvin Walberg on July 27, 1896, in Pine City. In Royalton Township, he could be found throwing balls into a milk pail tied to a tree. Walberg was 26 years old when he broke into the big leagues on April 29, 1923, with the New York Giants. The Giants, after paying a lot of money for him, let him go to Philadelphia. He played for the Athletics until 1933, where the six-foot, 185-pound pitcher pitched 547 games. He batted and threw left-handed. His finest years were from 1929 to 1931, when his team won three pennants and he won 51 games. His best year was 1931, when he recorded a career-high 20-win season (20-12). He pitched the winning game in the World Series of 1929, which made Philadelphia champions. In his 15-season career, he posted a 155-141 record with 1,085 strikeouts and a 4.16 ERA in 2,644 innings. That included 15 shutouts and 140 complete games. Walberg died in Tempe, Arizona, on October 27, 1978. In 2002, he was inducted into the Philadelphia Baseball Wall of Fame.

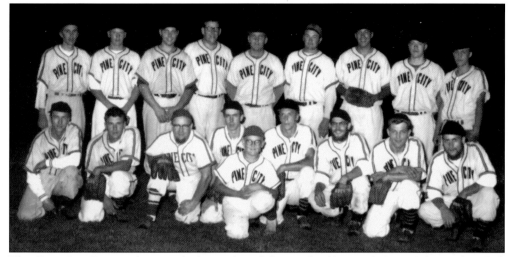

This Pine City Pirates photograph shows, from left to right, (first row) Gene Schumacher, Bob Kozisek, unidentified, Don Mohr, batboy Miles Backstrom, Rasty Thorson, Lenny Mohr, Gene Pavelka, and Joe Piha; (second row) Bayliss Swanson, Oscar Thorson, Gene Lewis, Cliff Dorow, Harvey Leuth, Ken Hawkinson, Dell Bethel, Doug Bloomberg, and Jerry Yost. The Pine City Pirates baseball team featured mostly local players from around the area and competed in the Eastern Minny North League, which is part of the Minnesota Baseball Association. The Pirates have had several state appearances, 1950, 1952, 1953, 1961, and 1962, in cities from New Ulm to St. Cloud. Two back-to-back years, 1952 and 1953, the team took second and third place, respectively, in the state tournament. It had a 14-game winning streak in 1948, the year the field was lit at the fairgrounds. It ended 16-2 with a loss to Hinckley in the playoffs. In the team's best season, 1952, the regional tournament was held in Pine City beginning on Friday evening, August 29, with the upper Mississippi entrant facing the eastern Minnesota playoff champion. Pine City defeated North Branch 4-1 in the first regional game to make its way to the state tournament in Austin. There the Pirates first met Madison and took their momentum all the way to finals, where they fell to Soderville 15-5 to take second place at state. (Courtesy of Bob Thiry.)

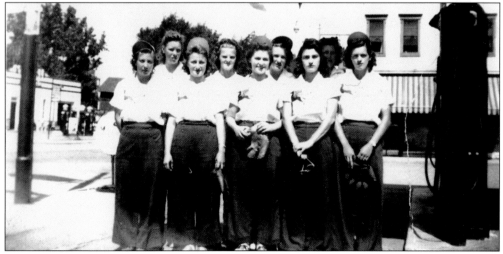

This photograph is of a Pine City softball team that made its way to play in the Aquatennial Tournament in 1941. (Courtesy of Jennie Olson.)

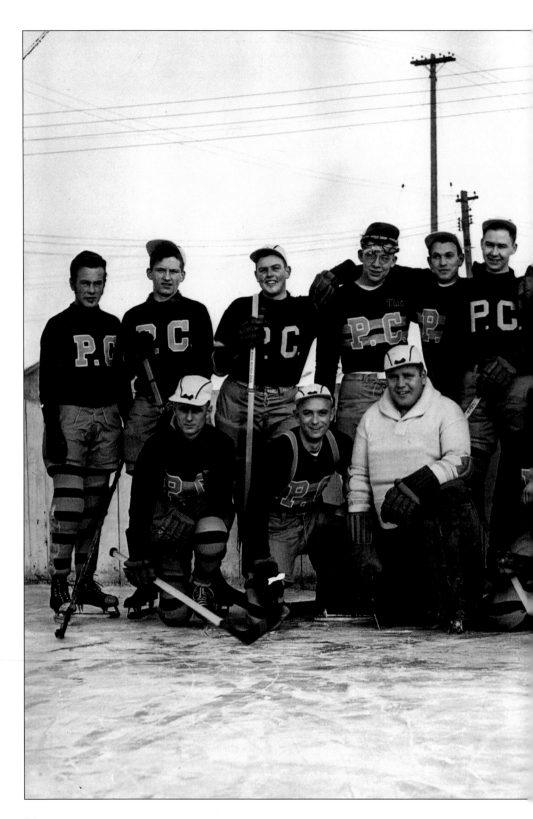

This photograph is of an early village hockey team. Pictured are, from left to right, (first row) Donny McKusick, Johnny Lindquist, Richard Cherrier, ? Soderstrom, and Donny Mohr; (second row) Lee Teich, Paul Rydberg, Raynold Pangerl, Bob McGregor, Johnny Grover, Allen Walberg, Hubert Skalicky, Stan Schnapp, ? Soderstrom, and Walter Johnson. The first all-girls hockey team was formed in 1976 and was in existence for one year only. The girls were coached by Susan Rydberg-Sauter and some of the skaters were Liz Bedahl, Mary Sauter, Mary Johnson, Dolly McGregor, Laura Bean, Renee Erfourth, Michelle Kappes, Susie Korf, Carmen Mattison, Susie Pangerl, Susan Sherman, Brenda Wanous, Teresa Thiesen, and Kelly Thiesen. (Courtesy of Joyce Lindquist.)

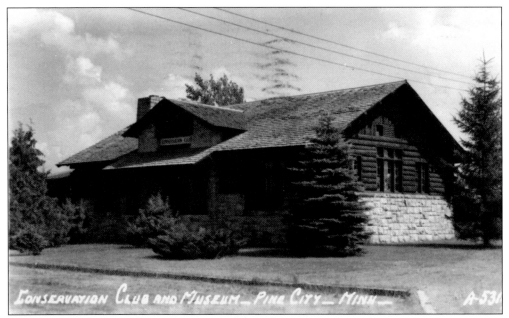

This photograph shows the Conservation Club and museum at Pine City.

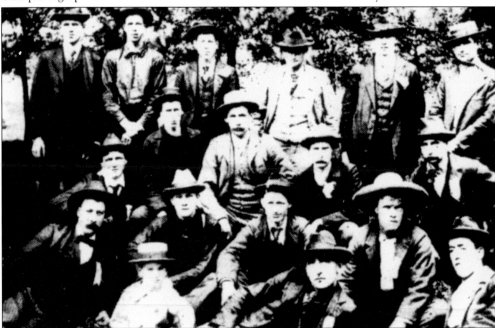

This photograph was taken on July 18, 1894, and shows Pine City's Owl Club. It got its name from the fact that its members, busy working by day, could only meet at night. According to member Fritz Johnson, it helped keep its members out of the saloons. Pictured are, from left to right are, (front row) mascot Bernard Lambert and C. Currie; (second row) Silas Louks, Mike Hurley, John Connaker, John Anderson, and Lee Fairbanks; (third row) Henry Glassow, Jim Haywood, Thomas Fitzgerald, A. E. Webber, and Mario Edwards; (fourth row) Fritz Johnson, Art Shultz, Andy Conner, Jerry Conner, Ed Netzcer, and William Lambert. (Courtesy of Pine City High School.)

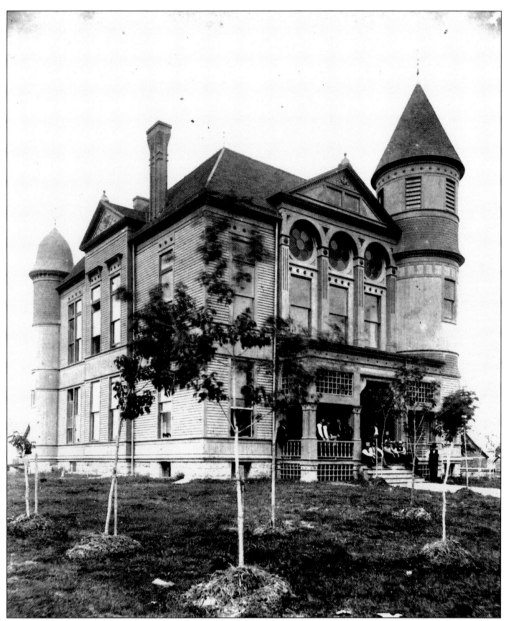

In 1872, the county seat was moved to Pine City by popular vote since the Superior-Mississippi Railroad now connected St. Paul to Duluth. A courthouse was built that year on the corner where the Nicolls Café now stands. When the elaborate courthouse was completed in 1886 in the square to the south, the first small building was moved from Main Street and used as a residence. This large beautiful courthouse was constructed in 1886. Notice the young trees. (Courtesy of Pine City High School.)

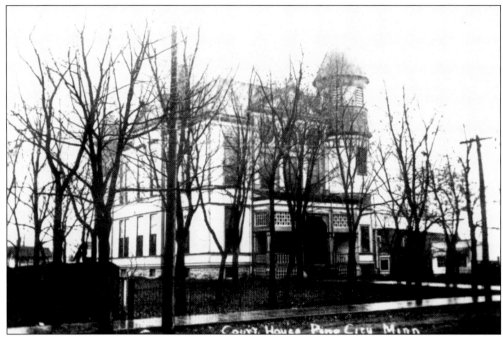

Heated by woodstoves and lit with kerosene, it cost $10,000 to build this courthouse. Local citizens held the old structure in high esteem.

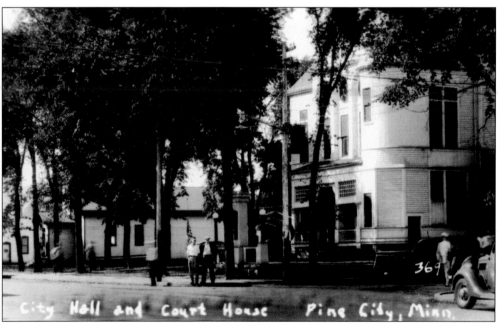

A lot of activity was generated in downtown Pine City due to the courthouse functions. However, some Hinckley "ruffians" reportedly set out to burn the courthouse in 1915, on the eve of an election to determine whether to move the county seat north.

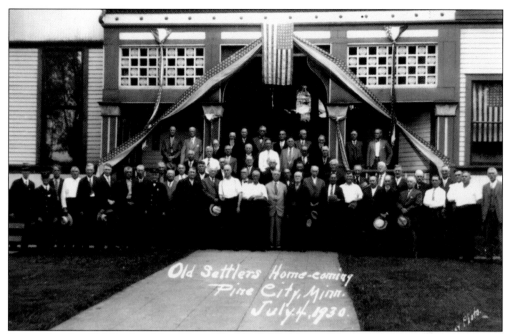

Pictured is the Old Settlers Homecoming in front of the courthouse building on July 4, 1930.

On June 12, 1952, the beautiful, ornate building was struck by lightning, resulting in considerable damage to the attic and water damage to other areas. It was deemed not salvageable by county officials and torn down. Notice in this photograph the first memorial dedicated to Pine City's service people.

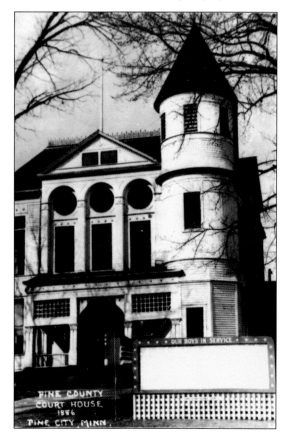

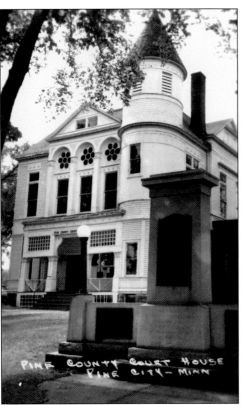

Later the monument in this photograph was erected in front of the courthouse as a memorial for service people from Pine City.

The Pine City Fire Department was once located in the same building as the village hall and county courthouse, on the south side.

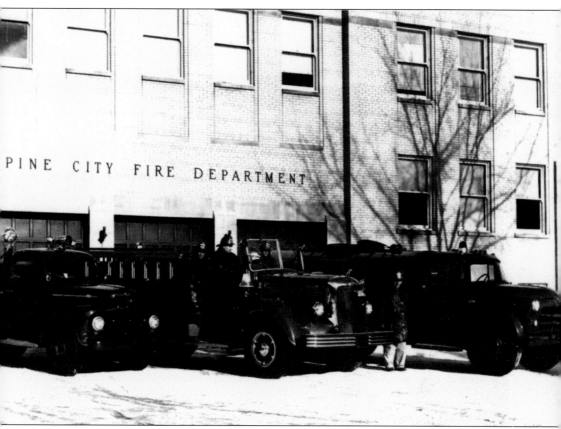

In a bond issue in 1954, which included the library, the county raised $160,000 for a new courthouse. This was built of identical brick on the north end of the one-time city hall, using the same marble wainscoting and terrazzo floors but with an entrance on the north. Over the entrance are carved the words *Pine County Courthouse*. The 1954 building retained some of the old city hall detailing; more recent additions depart from it, although they use the same brick. The previous Pine County courthouse was originally to be a city hall. Those words are still carved above the door on the long facade as it turns to Main Street. The plain, yellow brick, two-story rectangle was built with the help of the Federal Emergency Administration of Public Works in 1939. Thomas J. Shefchik was the architect. Pine City had become apprehensive about losing its status as county seat to Hinckley. Hinckley had put a vote for the change on the ballot some years earlier, losing by only a small margin. So Pine City made a gift of its city hall to the county.

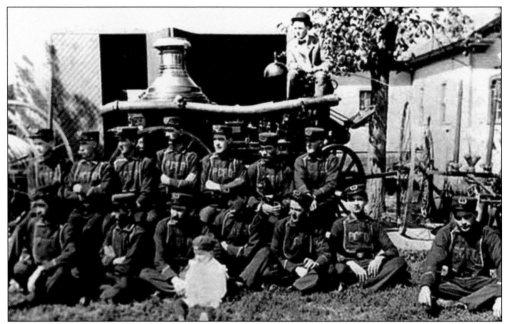

This photograph shows Pine City's original fire department as it posed on July 4, 1900. Members pictured are, from left to right, (first row) William Gottry, Emil Hoefler, Thomas Lanz, Dr. Robert Wiseman, Frank Poferl, Lawrence Poferl, and unidentified; (second row) Jack Lambert, Frank Maden, Fritz Johnson, Walter Gottry, R. G. Hawley (chief), Robert M. Wilcox, and Nick Perkins. Seated on the engine is Paul Perkins, who happened by when the photograph was taken. The little boy mascot in the foreground is Edgar Vaughn.

Just four years after the great Hinckley fire, when that town and its fire equipment were destroyed, Hinckley had modern fire equipment while Pine City had only a bucket brigade. Very little was left of Pine City, so the village council decided to purchase a steam pumper (as shown in this photograph), two hose carts, and 1,500 feet of 2.5-inch fire hose. The successful bidder was Waterous Engine Works, at $2,300.

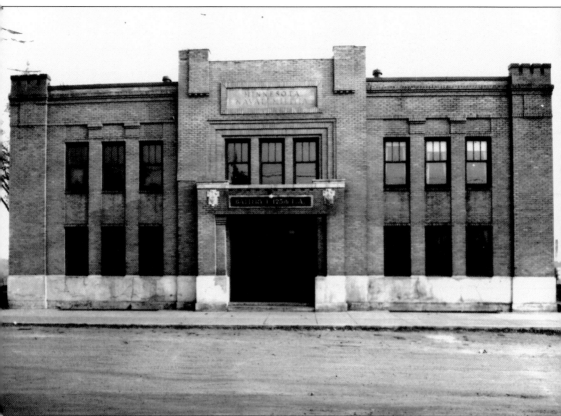

Pine City's naval militia armory was one of the few naval units over 100 miles from water. The 3rd Division of the Minnesota Naval Militia was organized in Pine City in 1913. Robert M. Wilcox was one of four men, the others being J. Adam Bede, Fred Hodge, and Karl Knapp, credited in getting the original armory built in Pine City. Wilcox was a Democrat and had a relative who served in the U.S. Army under the supervision of Col. Henry Sibley, which aroused his interest in the military service. The building was at one time listed on the National Register of Historic Places but was later demolished and removed from the list in 2001.

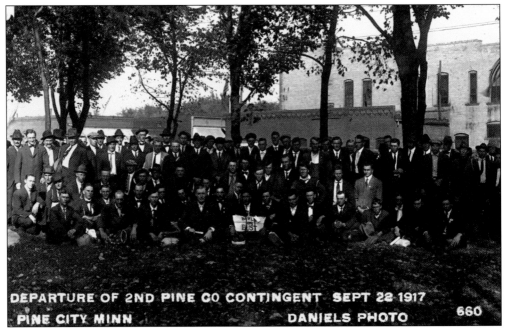

The division was called out on the declaration of war with Germany on April 6, 1917, reported at the Philadelphia naval yards on April 10, and was assigned quarters on the USS *Massachusetts*. These photographs depict the departure of the second Pine County contingent to depart, on September 22, 1917.

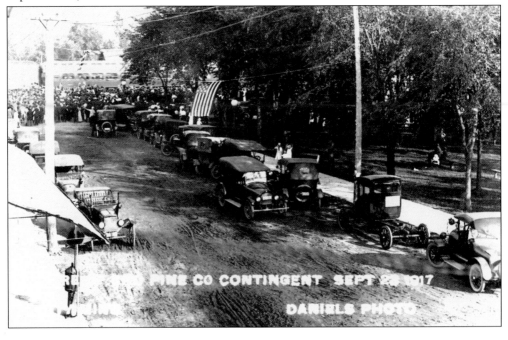

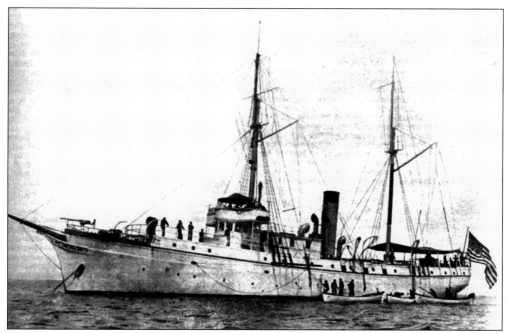

Robert M. Wilcox was a lieutenant. The Pine City militia served on annual Great Lakes cruises aboard the USS *Gopher* (shown in this photograph) from 1913 to 1916. It drilled once a week and trained for two weeks on the ship on the Great Lakes every summer from 1913 to 1916 but was subject to call into service by the U.S. Navy whenever needed.

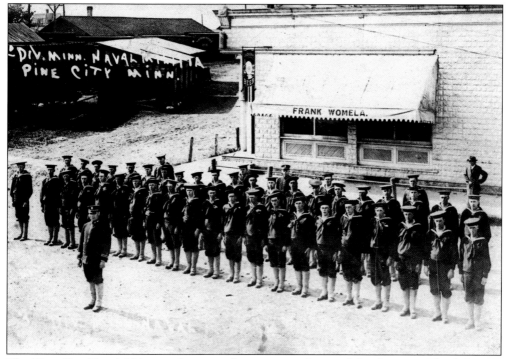

The Pine City Naval Militia is shown in formation southeast of the depot on Third Avenue around 1914.

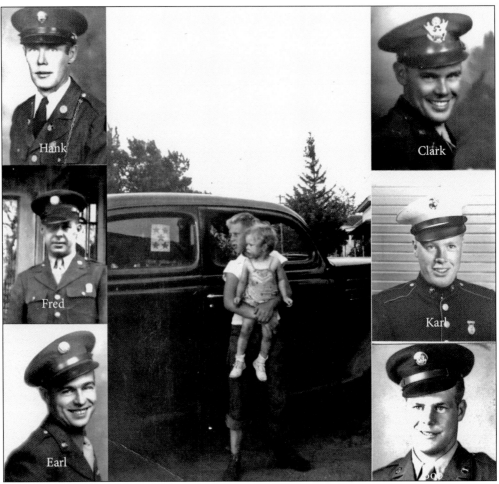

This 1944 photograph shows Anna Foster's youngest son, Art, and granddaughter Sara Foster looking at five stars in their car window. Anna had five sons in the service (World War I) at the time this photograph was taken. Her sixth son, Bob, entered the service a few months later. Anna was fortunate she never became a member of the Gold Star Mothers Club.

Five
STANDING TALL

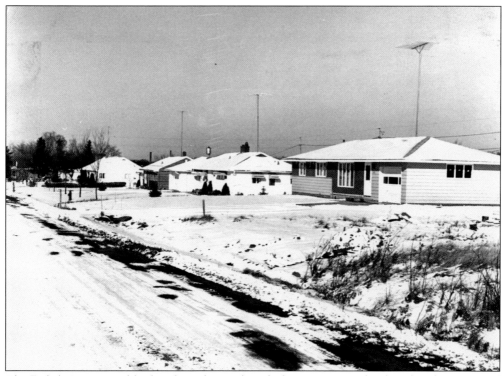

The Eighth Street Neighborhood, on the south end of Pine City, was developed in the 1960s and for years was considered the "upscale" part of Pine City, having been the newest development for a time. In this photograph, looking toward the former water tower, one can see rooftop antennas that are no longer necessary for broadcast television. (Author's collection.)

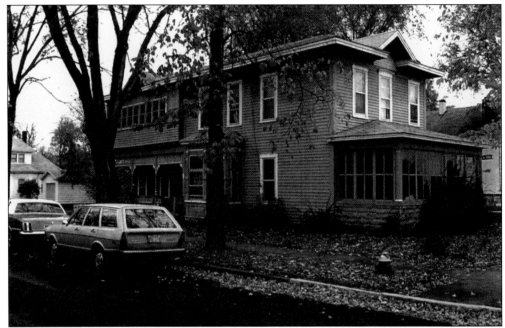

The Hurley house, located along Seventh Street Southwest, was considered one of the largest and finest residences in the entire city and in this section of the state. The photograph was taken in October 1979. James Hurley was involved mostly in real estate, owning a lot of unimproved lands in Pine County as well as business and residence lots in Pine City. He located here in 1871 and for 14 years served as register of deeds, then engaged in the wholesale liquor business. During the Hinckley fire, whistles and church bells sounded in Pine City, and an impromptu gathering of Pine City residents occurred at Robinson Park to decide a course of action. Hurley was elected chairman of an emergency relief committee.

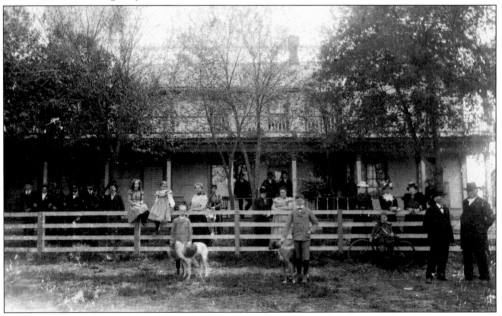

This is an earlier view of the Hurley house. (Courtesy of Pine City High School.)

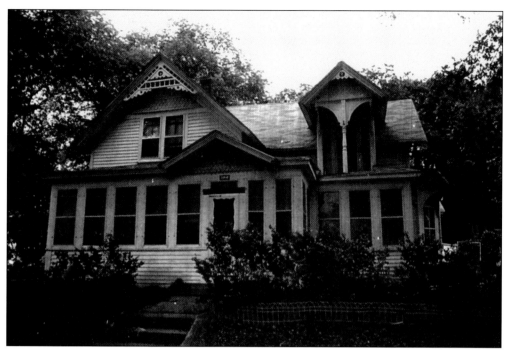

This photograph of the Beidermann house was taken in 1974. Adam Beidermann, born in Star Prairie, Wisconsin, in 1868, was the local agent for McCormick machines. He settled in Pine City in 1890 and had the largest implement dealership in the area. His first enterprises in Pine City were as a blacksmith and in horseshoeing. He was married with four children.

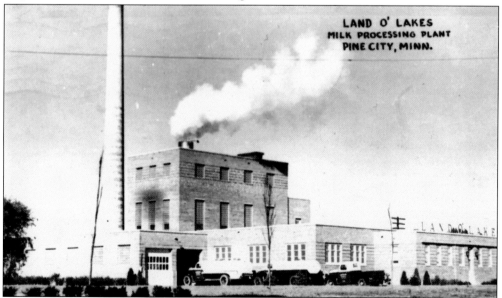

The huge Land O'Lakes drying plant contributed to the chance for employment for the residents and drew new people to the village. The products from this and other Pine City industries were sent far and wide in the nation. Four employees came from the Pine City Cooperative Creamery to work at Land O'Lakes when it first opened, including Ben DeBoer, Lawrence Tollefson, and Bernard Felton. At its prime, the plant processed 1.5 million pounds of milk per day.

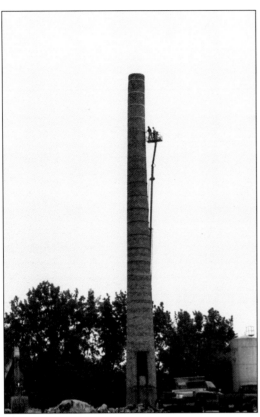

Land O'Lakes closed in mid-1984 and was sold to New Generation Foods, Inc., a company that engaged in the drying of high-fat-content products, to be used in the manufacturing of human and animal foods. This is all that remained of the plant during the demolition of it in the 1990s to make room for redevelopment (waterfront townhomes). (Author's collection.)

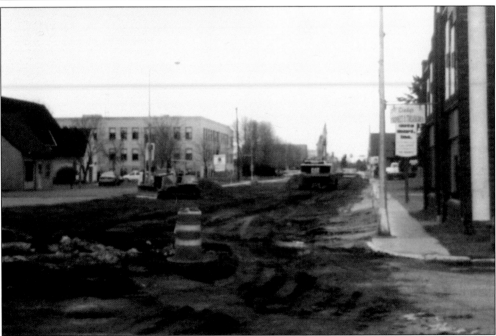

This photograph shows the Main Street (old Highway 61) reconstruction in 2001. The three-story building on the left is the third courthouse in Pine City. (Author's collection.)

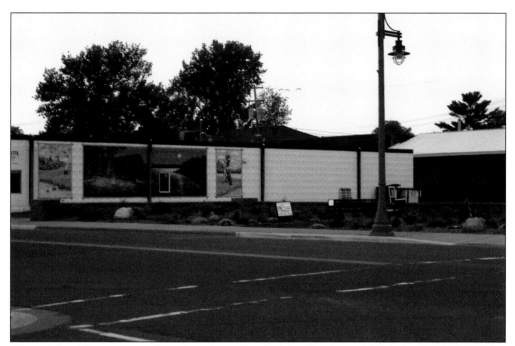

Along Main Street, several gardens have been planted as part of a beautification project. (Author's collection.)

Along Main Street and Hillside Avenue, decorative lampposts and banners have been placed. The lamps along Main Street throughout downtown are oriented toward pedestrians on the sidewalks as well as toward the roadways. (Author's collection.)

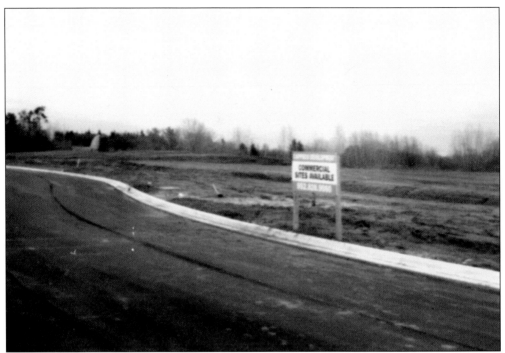

The city's north interchange has been developing at a steady pace in recent years. This photograph is advertising commercial land that was for sale near the interchange in 2001. (Author's collection.)

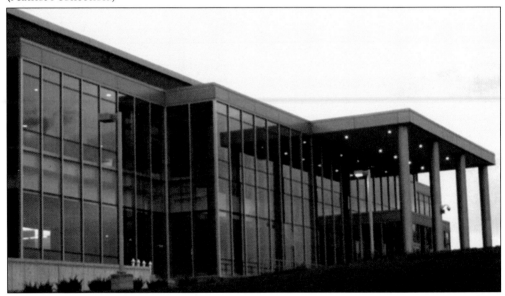

In October 2007, a new $28 million courthouse was completed in the vicinity of the city's northern interchange. Pine County's courthouse relocated to its current location. The new facility is three times the size of the 1872 original. Departments located in the new courthouse are assessor, attorney, auditor, court administration, coordinators, extension, health and human services, homeland security, human resources, probation, recorder, sheriff, and the treasurer's office. (Author's collection.)

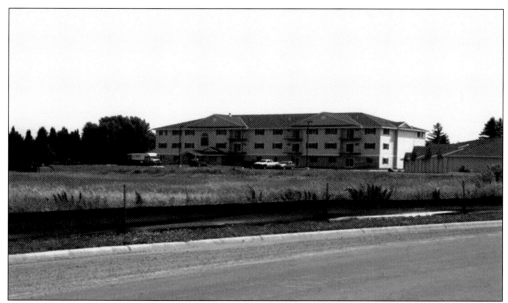

In 2009, there were over 500 rental units within the city. This is a newer apartment complex, Northridge Apartments, on the city's developing north end. (Author's collection.)

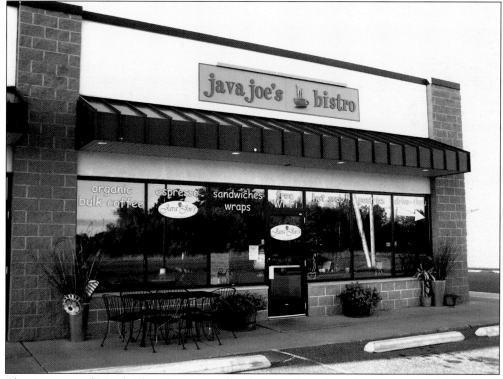

This is a part of Northridge Center, on the city's northern interchange, occupied by a small bistro. (Author's collection.)

In recent years, the community has seemed to embrace a log theme, with several local businesses incorporating logs into their facades. (Author's collection.)

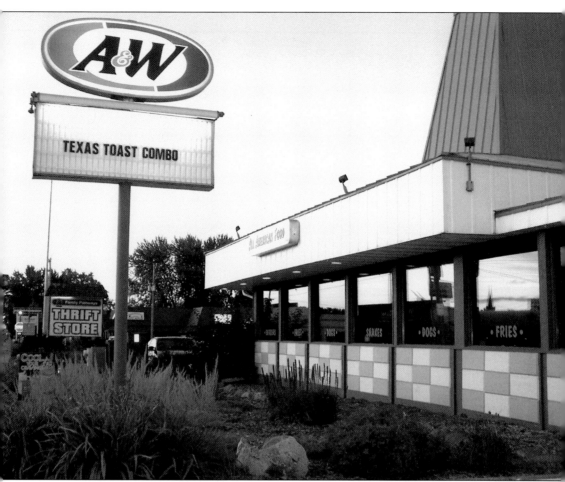

The community still caters to the automobile, especially along old Highway 61. Shown here is the A&W, located along the highway since 1955, one of the few remaining carhops in the area. (Author's collection.)

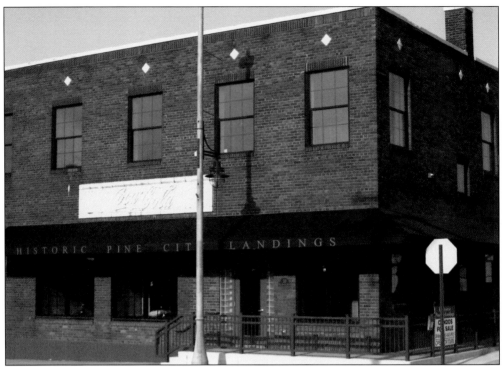

The former Coca-Cola bottling plant has been converted into waterfront condos, the Historic Pine City Landings. Waterfront redevelopment, especially downtown, has occurred at a brisk pace in recent years. (Author's collection.)

Downtown has remained relatively intact over the past century. This 2007 photograph looks southwest toward the Rybak Building. (Author's collection.)

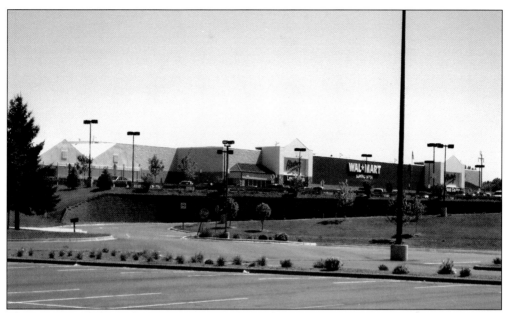

This is a view of the Wal-Mart Supercenter, located near Evergreen Square Mall, which opened in 2007. Pine City's original Wal-Mart was built in 1996 and was demolished to make room for the new store. (Author's collection.)

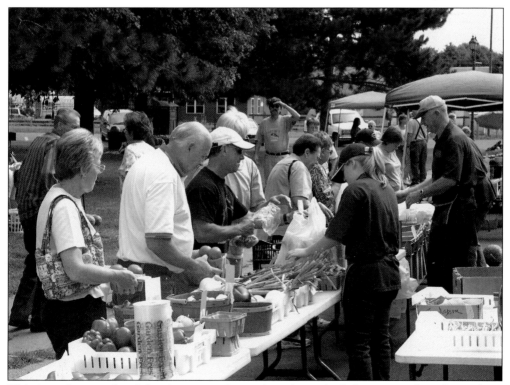

This is a photograph of the downtown farmers' market, which has seen a lot of growth in recent years. (Author's collection.)

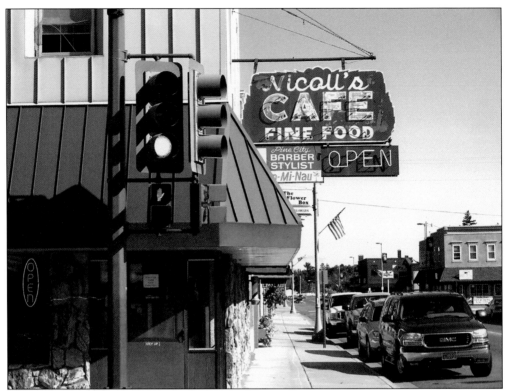
This is another view of Main Street, near Third Avenue. A corner café has been a staple of this intersection for decades. (Author's collection.)

Pictured is the downtown Miller Block, established in 1898, as the block looked in 2007. (Author's collection.)

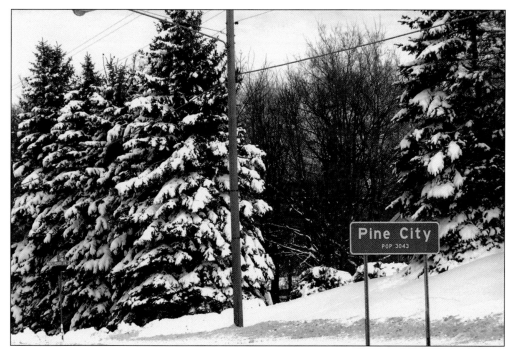

This snowy view shows the entrance to Pine City, which has a population sign that shows 3,043 residents at the 2000 census. (Author's collection.)

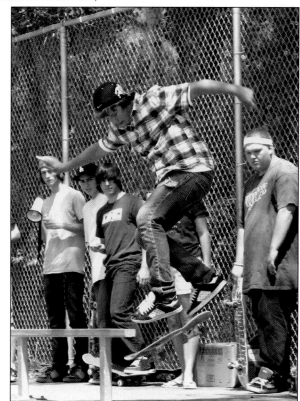

The city has developed a beautiful park system. One of them, Westside Park, is home to a skateboard park and the city beach. This photograph is from a skateboard event that took place in 2007. (Author's collection.)

The Christmas trees that adorn the Minnesota governor's residence on Summit Avenue in St. Paul have fittingly often come from the Pine City area. This photograph shows a tree from the Chengwatana Forest, from a recent holiday season when no snow had yet fallen on the ground. (Courtesy of Mary Pawlenty.)

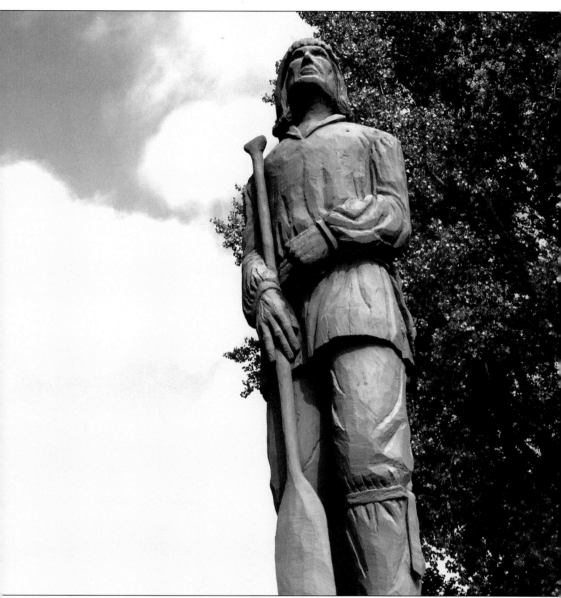

This is the Voyageur Statue, reminiscent of the days of the French voyageurs who traveled through the area on the Snake River. It was carved out of redwood by Dennis Roghair and is 35 feet tall. It sits near the north shore of the Snake River, overlooking downtown, and wears a Santa hat each holiday season. The roadside attraction is a popular stop for tourists traveling by. (Author's collection.)

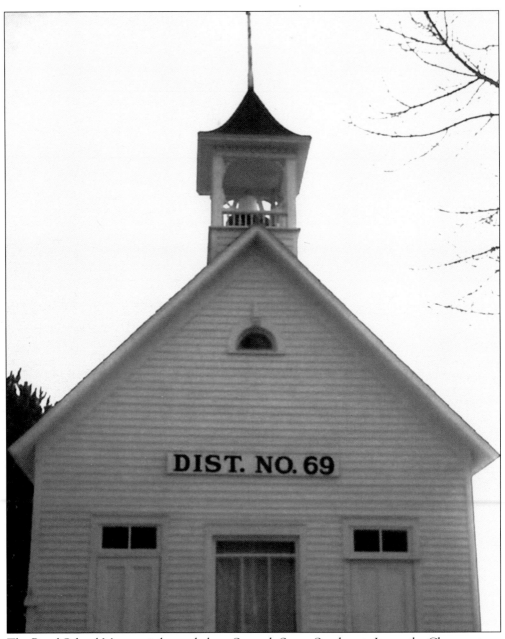

The Rural School Museum is located along Seventh Street Southwest. It was the Chengwatana School District No. 69 and restored as a historical attraction. (Author's collection.)

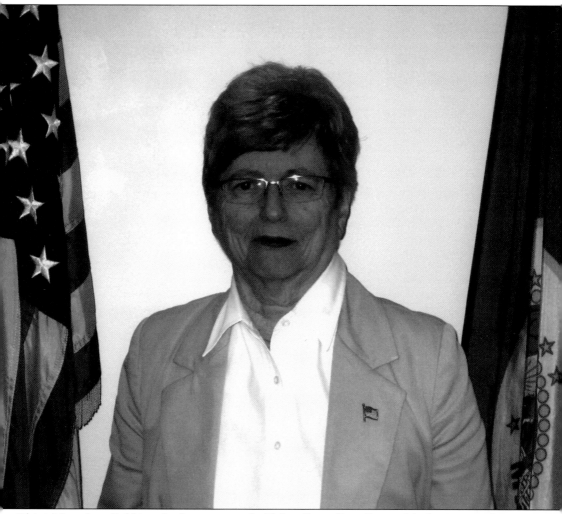
This is Mayor Jane Robbins, the first woman to hold the office in Pine City and the longest-standing mayor in the city's history. In 2008, she was named the C. C. Ludwig Award winner, the League of Minnesota Cities' highest honor for an elected official. (Author's collection.)

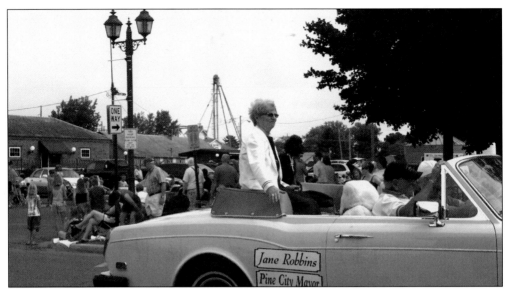

Mayor Jane Robbins and her husband, Gerry, moved to Pine City from Glendive, Montana, and purchased the local radio station, WCMP. The station had been in the community since 1957. Robbins served as a member and president of the Pine Area Lions and had the honor of being Pine City's Citizen of the Year in 1983. She has served as mayor since 1992 and was on the city council from 1977 to 1986 and since 1987. (Courtesy of the Pine City Pioneer.)

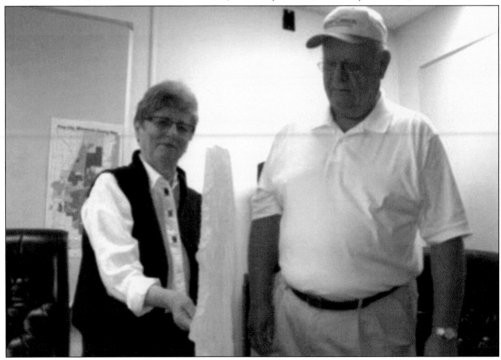

Here are two of Pine City's mayors, Jane Robbins and G. Richard Clemenson (1976–1978), standing together, admiring the city's award for being named Outstanding Community, received from the Initiative Foundation in 2009. Clemenson was visiting from Detroit Lakes, where he and his family moved after leaving Pine City. (Author's collection.)

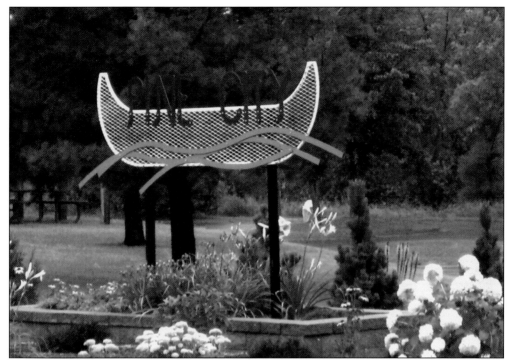
These canoe signs welcome motorists to Pine City from the north, south, and west. (Author's collection.)

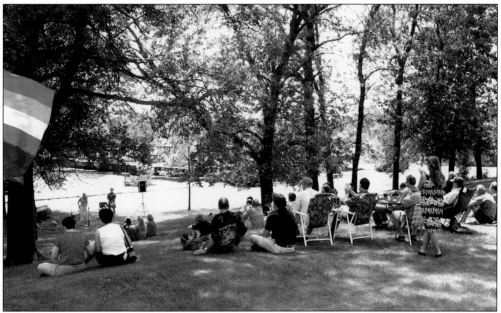
Many annual cultural events are held in the community today. Although protests took place two years, since 2005 Pine City has been the site of Minnesota's first rural gay (GLBT) pride event, the second such event in the nation (shown here in 2006). Other annual cultural events include the Czech Booya Festival and the North West Company Fur Post's fall gathering. (Author's collection.)

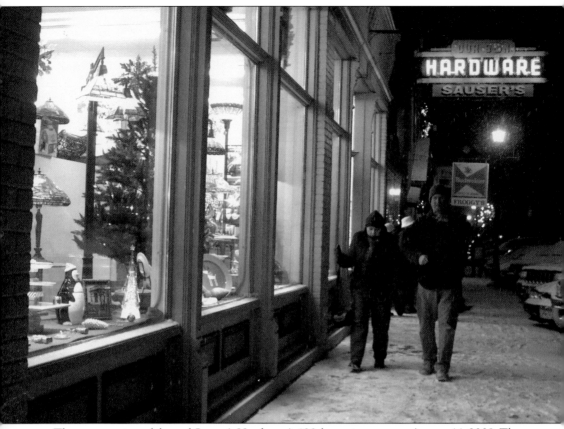

The community celebrated Sauser's Hardware's 100th anniversary on August 14, 2009. The store is pictured above during the holiday season of 2008. (Courtesy of Vicki Foss.)

Bibliography

Brown, Daniel James. *Under a Flaming Sky: The Great Hinckley Firestorm of 1894.* Guilford, CT: Lyons Press, 2006.
Cordes, Jim. *Pine County . . . and Its Memories.* Askov, MN: American Publishing Company, 1989.
Gallick, Rev. George A. "Woodpecker Ridge: What's in Its Name?"
Kick, Harold. *Chinese Laundry.* St. Cloud, MN: Sunray Publishing, 2007.
"Memory Lane." *Pine City Pioneer,* 1994–2002.
Pine County Historical Society. *One Hundred Years in Pine County.* North Branch, MN: Review Corporation, 1949.
Souvenir . . . Pine City, Minnesota, A. Minneapolis: Wall and Haines, 1901.
Vach, Mrs. Steve. *Notes on the History of the Pokegama Sanitorium.* 1985.
Warren, William Whipple. *History of the Ojibway People.* St. Paul: Minnesota Historical Society Press, 1984.
www.co.pine.mn.us

Discover Thousands of Local History Books
Featuring Millions of Vintage Images

Arcadia Publishing, the leading local history publisher in the United States, is committed to making history accessible and meaningful through publishing books that celebrate and preserve the heritage of America's people and places.

Find more books like this at
www.arcadiapublishing.com

Search for your hometown history, your old stomping grounds, and even your favorite sports team.

Consistent with our mission to preserve history on a local level, this book was printed in South Carolina on American-made paper and manufactured entirely in the United States. Products carrying the accredited Forest Stewardship Council (FSC) label are printed on 100 percent FSC-certified paper.